Copyright © 2010 by Gregory Atkins.

Library of Congress Control Number: 2009906597
ISBN: Softcover 978-1-4500-1990-3

All rights reserved. No part of this book may be reproduced or transmitted in any form or by any means, electronic or mechanical, including photocopying, recording, or by any information storage and retrieval system, without permission in writing from the copyright owner.

This book was printed in the United States of America.

To order additional copies of this book, contact:
Xlibris Corporation
1-888-795-4274
www.Xlibris.com
Orders@Xlibris.com
62420

Where to Find me

WRITTEN & ILLUSTRATED BY

GREGORY ATKINS

Where to Find Me

rediscovery and redefining life through self analysis

Introduction

It was a late night. I was on the telephone longer than usual. My father and I talked for hours. There were 250 miles between us. We had a conversation about that one thing which most of us wish to avoid. Death was the topic. Metaphorically, he went into a deep hole and climbed back out as he illustrated the deed of dying and our never knowing end to what we consider life. At that moment I realized that life was more than just a temporary thing that we must one day say farewell to. I grasped an understanding that allowed me the opportunity to see death as something more than just taking a last breath. I learned that **Death is Life**. In order to live after death, we must have taken advantage of the opportunity to live in truth and within a realm of devotion. To truly live means to accept who we are and to be overly gracious to our maker for what we have by way of demonstration. Unfortunately, time doesn't allow us the opportunities to really reflect on much more than that. Embedded deep within each and every one of us is a desire to extend comfort upon someone else's life, whether it pertains to children or our fellow man. Often, we simply do not always have the insight to fulfill this passion.

We must open our minds to teach those who shall learn and guide those who shall follow. We are destined to accept such obligations. We must open our homes to those who shall stay. We must love unconditionally those who shall be loved and even those who are reluctant and evasive to such idea. With this new way of examining death and life I scrambled in my attempts to highlight this remarkable insight that I had been given. My ambitions formed into a non yielding quest to present as much meaningful information as I could to others, to you within an understandable formant that could be examined over and over at one's convenience in a dual and universal way. Through visual art and the written word, I came to such conclusion.

It is my desire, my hope that you will recognize yourself in many of these pages as I have. It is my greatest wish that after you travel through and beyond this book you too will find new meaning to your life and the success you may achieve during your last moments on this place called earth.

Without warning, physical life may quickly pass before we have the opportunity to make an impression on the lives of those whom we inspire. So, it should be our goal to succeed at living before our visitor arrives and takes us to that place where redemption may never be discovered.

How to use this book

WHERE TO FIND ME is a compilation of ideas through passages that are divided into 10 sections – 10 weeks. Each section is calculated and grouped within five consecutive days. Those days are Monday through Friday. For many of us, these days represent the highest levels of stress due to the enormous responsibilities and challenges we face during the week. Each day signifies a place in time, a focal point based on an interpreted spiritual principle, and an exploration of the intrinsic make up of individuality.

Read a passage daily, starting with that present day. Then challenge yourself mentally, as you explore the visual illustrations on the facing page. Engage methodically in subjects of commonality. Accept those unforeseen elements that may be revealed. Each illustration is a composite of the text on the opposite page. Both are forms of language that generate comparable ideas of similarities. One is merely a mirror image of the other, expressing views by way of distinct means.

By the end of this experience you should have witnessed past beliefs & interests, sentiments, judgments, and ideas that may have become forgotten and ignored. Often, these are the very things that enable us, shelter one's progress further behind our own minimal thoughts, and places us in total recession.

These elements in life, which cause each and every one of us heartache, pain, and confusion often set limitations toward those advancements which could illustrate our truth.

Analyze the newness of your thoughts and make progressive change.

The significance of 10 weeks

Imagine 10 people close to you dying within a short period of time of each other . . . Now, imagine that those people are all 12 years old and younger.

Just like many, there was a time in my life when I suffered from depression. It was an experience that I will never forget, one that I would never wish upon the shoulders of anyone. My life was broken. It had vanished into something unrecognizable, something that was not paralleled by anything I had ever encountered. The deepest thoughts hung over me in a twisted form of complexity. They were arbitrary in meaning, cluttered within confusion. I thought there was no reason to live, no love within the atmosphere where I breathed, no substance in the food of life which I devoured, and most of all I felt that there was no meaning to my life. So, I made up in my mind that I would not give up so easily. I began using the one thing that gave me hope, the very element which inspired my faith. Through prayer I was convinced that I did have a purpose. I developed an outline which gave me a sense of self worth. The process was fascinating, but difficult.

As time passed I began realizing the shortness of life. Memories of those important things lost began to consume me. I can remember waking up one early morning, turning the television on, and hearing of one of the most tragic incidences. There was a nine year old boy who drowned that day. He was wearing a life jacket when he fell from a fishing boat. His grandfather attempted a desperate rescue, but his endeavor proved to be that of the same fate. He also lost his life to the relentless waters. It was days later when a rescue team discovered both lifeless bodies floating down stream. The little boy's name was David.

The tragedy of death is indeed a sad one whether it is an elderly person passing away from old age or a child at the tender age of 5. However, the circumstances are all too common. Each day we are engrossed by informative bulletins, which cater to the vast occurrences of death. Although natural, it is happening at a non yielding rate. In fact, we learn of someone leaving life behind far too often. As a matter of fact, I learned of a tragic car accident, which claimed a person's life just 2 minutes prior to writing this. Seemingly, the news media is so comfortable with describing these occurrences regarding death that they effortlessly move from the topic of a mass murder to one regarding new food products. However, the journalists are not to be frowned upon. They are merely a means to inform the public of events. We are all to blame for the comfortable acceptances of people dying. In actuality, it is a topic that doesn't' even get much thought after its revelation. We hear of it and make a comment like "Oh, that is so awful." Without even blinking an eye we turn towards the kitchen to fix ourselves a bowl of homemade vanilla ice cream. Then we spread caramel on top of it just before the crushed almonds. Next, the whip cream is added. The thought of death is consumed along with the first taste.

It is sad to say that more time is taken out for snacks than it is for the remembrance of life. That is partially how I viewed society before my perceptions found reasonable change. The ten weeks that changed my life came to settle upon a memory which forced me to recognize life as something of a greater power. Many of those transitions began to occur during my very first year as an educator. It was the second semester when CHANGE entered my classroom.

She sat down at a table located in the center of the room. It was covered with markers and crayons and two sheets of drawing paper. I was expecting her.

I stood nearby ready to give instructions and begin the days activity. Before I could get started I noticed my new student, Abeni eating the crayons. I realized that the yellow one had already been eaten halfway when she was starting on the red. I moved quickly towards her. I sat down beside her and tried to explain the use of the material. She did not understand. Abeni was from a small secluded village in West Africa. She had only experienced very little education there. Commonality there was nothing comparable to that of this country. Never before had she seen crayons. Never before was she introduced to an art class in the formal sense. Successfully, I managed to enlighten her, so I thought. Within minutes, she followed suite right along with the rest of the students in class. I began a demonstration. Minutes later, at the front of the room, I felt a projection of weight escalade onto my back. The force moved me toward the chalkboard. My face leveled with the green field. I struggled to dismount my attacker. An uproar soured throughout the classroom. Laughter and children yelling consumed the tiny space. Once I broke free I moved abruptly in search of a safety zone. When I came back down from my exalted high which the unexpected excitement had caused, I realized something very strange. I saw that it was Abeni who had plunged the attack on me. I looked down at my hand and realized the reason for this juxtaposed behavior of hers. In my hand was the box of crayons that I had taken from her table. She wanted it back, but just didn't understand how to go about it.

Now that I look back, that moment was indeed comical. There is no classroom experience that has been more profound in the tenure of my career. I will remember that moment forever. Unfortunately, there is something about her that overshadows any comic relief that is said memorable. The day she died was devastating. It happened many months later. I remember the moment I got the news. I sat down, looked into the heavens trying to understand why something so terrible could have happened to such a sweet child. I couldn't understand. I didn't want to believe or accept the fact that this girl had just witnessed the last moment of her life. The anxiety was far greater than anything that I could begin to fathom. As far as I was concerned at that moment, that fact had no possibilities.

I wanted to awake from such a horrific nightmare, but I couldn't. I was consumed. An angelic face cascaded through the dark clouds that hovered over me. Anticipated, sweeping wind of calming peace never assumed my presence. I stood in the moment of nothing real, nothing that could find acceptance for being the truth. Tears flowed down my face like a flowing stream. I was nothing. There was no worth inside of me that could have given reason for my living. There was no worth in me which was greater than that which once thrived in Abeni. Days later at her wake, I saw her. She laid without pain. A smile on her face was more than I could bare. The delicate flaking polish on her fingernails spoke of her innocence. A small child laid. Her life never developed into maturity. Prosperity within her dreams were never to be fulfilled. That which claimed her had placed her in a room where she could never again touch and kiss her mother with loving adornment. At that moment, Abeni had all that I could have ever wished for. FREEDOM. I moved on from that experience heartbroken, but with a different walk. My stuttered step became that of a more hopeful and gratifying swagger. I began to see how short life really was.

During my second year I never once forgot about the little girl from Africa. Never did I think that I would experience the death of another child. I mean, it wasn't something that I considered. It was too far from my reality. However, I soon realized that my ideas were foolish within the

realm of life's cycle. That year Ruby died. She experienced an amorism just as Abeni had. She didn't even get the opportunity to become a teenager.

A week later, Michael and Sonya, two children that attended my church, were involved in a car accident. A drunken driver ran through a stop sign, killing Michael instantly. Sonya died the following week from multiple injuries.

Year three claimed the life of Dante. He was a bright student who seemingly had a prosperous future ahead of himself. He drowned in a swimming pool while horse playing at a friend's birthday party. That accident cost him his life. He would never become that professional ball player that he aspired to be.

May 29th, almost one year after Dante's death, Ana came over to me in class. She had a disturbing look on her face. I asked her if there was something bothering her. I could sense that there was because she sat extremely quiet, not engaging with her classmates as usual. She stated in the calmest voice. "Mr. Atkins, I am dying. I only have 3 months to live." Eyes wide open, I was dumbfounded. Speechless. I thought she was joking at first, but when I saw the intensity of her gaze I realized the sincerity in her voice. The bell rang and class dismissed. I stared at her, watching her silhouette fade into the flow of students moving about. I didn't know what to say. It was the very last time I saw her.

My fifth year came and I felt as if I were over the hump. I was off my self-proclaimed New Teacher Probationary Period. However, I would soon find out that I wasn't in any preparation for what was to come. Erica died. she was only 12 years young. I could not believe it. I had witnessed the death of so many children in such little time.

Dominique was shot dead at his apartment complex after getting into an altercation with his mother's boyfriend. He was attempting to protect his mother from the violent man. That was an unforgettable week. It was the week of my birthday. As I was welcoming a new mark on life, I was mourning the loss of my student who was protecting his mother's.

My 7th year nearly came and went without knowledge of any tragic circumstances that lead to a student's death, until the first week of summer break. One evening I was headed home from the grocery store. As I turned onto my street I noticed two patrol cars, an ambulance, and a fire truck. I parked, stepped out and watched as my neighbor's eight-year-old son was taken from the back yard by paramedics. He had abrasions covering his body. Blood ran from his face, beneath the large bandage that covered it. The ambulance hurled off within seconds. His father chased while the little boy and his mother sat inside hoping for a miracle. Sadly, that miracle never came. The little guy died moments after reaching the hospital. The torture that the family dog infringed upon him claimed his life.

The 8th year was a terrible one, in every since of the word. I was on my way to work one morning, almost dreading to get there. It was a Monday. I was a few blocks away from the school when I noticed the flashing lights of the ambulance and patrol cars. I merely thought that it was just one of the many fights that occurred between students walking to school. I had no idea that I was about to see a murdered child. In the middle of the lawn, a young girl laid. Her body lifeless, covered. The only parts of her exposed was her hand and foot that laid outside the white sheet which draped her body. She had been beaten and shot to death. Ironically, she died on the grounds of a church. The next week I stood in class checking the attendance when I received horrific news. "Jose. Jose. Does anyone know where Jose is

today?" I asked the class. No one spoke immediately. I called out to the student on 3 more occasions before I was informed of his absence. One student spoke out with heaviness on his voice. "Jose died this past weekend." Again, my head bowed from the horrific news that paralyzed my every emotion. This can't be happening again. It can't be. I thought to myself just before I felt the panic in my chest.

In ten different weeks, ten similar tragedies had changed my life drastically. Never would I have ever believed that those images would compel me so detrimentally. Never would I think of life the same. Surreal, they are in every way imaginable. Yet, the images are all too real in the same sense. Life has the tendency of demonstrating its unfairness's, but those misfortunes can and should create a vision of clarity within the living where all should see the importance's of life and be willing to appreciate the manifestations that will come. Not one death should be remembered in vain or thoughtlessly. Rather, each should be a reminder of what's to come. So, we must learn, love, live, and cast out all those things which prevent us from doing so.

It is something unpredictable, LIFE. There is and Never Ever should be anything more cherished. So, as we sit back in our new chair, drive our new car, sweep our new driveway, walk through the malls smiling with our plastic money, or even lying in bed with complaint about doing something that we are entirely capable of, let us remember in total that very thing which we have taken for granted. Remember the meaning of LIFE and how unmistakably relevant it is to living.

Worry-free yourself from those small changeable things that you hold on to with a steady grasp. Discontinue conversations of those empty episodes characterized by absolutely nothing important. Attempt at learning in the valuable sense, where meaningfulness can be understood and launched into prosperity. Do these things in remembrance of our loved ones and the many who vanished within death's shadow before their time.

It is time that we respected ourselves enough to not only value, but live the life we've been given with the highest regards and efficiency.

Acknowledgements

I'd like to thank my wife, Jennifer for inspiring me to write this book. She once said to me. "Words on paper are simply words on paper. However, when those words can foster a high level of thinking where inspirational growth can be achieved then those words become a powerful force of motion." So, to move the mind towards a greater freedom became my quest.

I thank my father for sitting me down at age 6, handing me a sketch book and drawing pencil, and telling me to draw what I saw before me. Ever since then I never looked for things to draw. Instead, they found me.

To Mr. Ernest Sterling, my 6th grade art teacher, for consuming me with art inspiration during my intermediate development. His attention and guidance in my life brought out a desire in me that was before hidden.

To Mr. Henri Linton, my college professor and art inspiration for taking me beneath his wing when I was just a lost bird in flight. He taught me that art is more than brush to canvas, but also a way of life that entails Everything.

And to all of you who have served as inspiring factors in which these words and artworks derive. It is for you that I write. It is for you that I create.

Contents

This book is for my loving mother, Essence, and my grandmothers Leola and Madi

*They have been the motivation in my life which has allowed me
the aspiration to succeed, endlessly*

&

To those ten innocent children whose shortness of life changed the meaning of mine

Your self-portrait

God will often form a conscience within us, one where we can no longer ignore our surroundings and what they have become. Each of us must dedicate ourselves to not only becoming better individuals, but also creating a format to better others.

We all are congested and compiled of multiple images that define who we are. We are palettes of paint constantly being mixed together, intertwined to create a new hue. Day in and day out we are witnessed by others through a portrait that we only want to display in obscured lighting. That portrait is an 8X10 glossy, and is presented in the most mediocre frame however, masked by potential. It highlights brief interpretations which we want revealed. Other's perceptions of us are illuminated through this image. A sense of strength, faith, beauty, and adornment can often be seen. Within this portrait we accomplish to hide many of our shortfalls and obscure our identity.

Housed much deeper within the core of us, hidden from the onlookers of the world is our smaller, wallet-size portrait. This is the one that is kept tucked away, only to be revealed in dire request and often not even then. Within the capacity of this portrait there is no smile present, no sense of acceptance by the vast world. Destructions in the form of failure, loneliness, bigotry, hatred, and ignorance can all be seen here. Yet, this forms the reasoning behind our attempts to shelter it. We have formed a complex of self-consciousness which creates no desire of letting others witness. Here we are lyres, cheaters, racists, and the lowest form of humanity. We are ashamed to reveal this portrait, embarrassed of the truths that lie within.

But further . . . farther into the distance, almost out of reach of our own vision stands a marquee – a portrait in the form of a billboard. There, reveals a portrait of whom we want to become, whom our potential tells us we can be. It is exceptional imagery that demonstrates success, helpfulness, love, achievement, precision, acceptance, and true passion. This portrait is remarkable. It glows within the strong rays that can only be projected by God. Here we smile a look of true happiness, a strength that has been cascaded by the love and passion we hold for others. This is the portrait we strive to acknowledge. Yet, the forces of our past continue to plague our movement and quest for such achievement. Those who surround us negatively as well as ourselves are the stumbling stones that postpone our arrival. We must stand in the midst of those negative things and pull ourselves closer towards this portrait.

Each of us must take a stand in creating our own marquee. A billboard of hope. Our portrait of peace. We must not allow the disadvantages of life to become our disadvantages of living. We must use our wallet-size portrait and our 8X10 glossy as foundations for creating a more complex and Godly image of whom we can be and whom we are destined to become. Only then shall we find ourselves. Our truth. Our worth. Only then will we know Where to Find Ourselves.

Week 1

To experience integrity's comfort one must acquire the responsibility to be committed to success

Integrity

The pain is worse when we fall from greater heights

Who's better – you or me?

Such a simple question can evoke an intrinsically excitement in some people. Others may cast their thoughts off within a capacity of humility. We all like to consider ourselves smart, wonderful, and even adorable. But are we? If we sit down, alone in a room with no particular focal point other than ourselves we may discover something that we have never considered about ourselves. You see, we all have sat around with our friends and associates and passed judgment on another person, particularly one outside of the room. Our mouths spill with insults, criticism, and negative opinions. This is perhaps done forcefully with something greater than envy and less than hatred. We do it because we feel as though we are better than they are by an arbitrary societal standard. Unfortunately, we often define ourselves by such measure. Maybe we feel this way because our Ivy league education is more appreciated by society than their small school experience. Maybe the car we drive gets more attention than the little sedan which they make their way in. Or our home has a more popular zip code than the smaller, rural town in which they live. Maybe we feel superior simply because of our race and what we have been conditioned to believe. Whatever the situation, we often lend ourselves to a definite lower standard. Not one person Is better than the next. This is a factual insight that we must learn to grasp and allow ourselves to understand. We have become evasive to what is real and sheltered within that which is not.

For many years and still, deprivation has played the greatest factor in the assumed standards of living. These standards have continuously been created by individuals who control nothing more than inaccuracy. Unfortunately, for many with twisted minds of false clarity, money doesn't make us better. Color will not make us better. Education doesn't make us better nor the influences that we place on those around us.

So lay aside thoughts of superiority because no matter which angle we look at ourselves we will never be better than anyone else.

Work at making yourself better than you are. Consider making better decisions.

Where to Find Me: in a mindset where the only judgments I shall place are those upon my own shoulders

The gossiper, 2009

Comfort

To love someone else you must love yourself most

For so many years you have considered yourself average. You have convinced yourself that you are not the most adorable person in the world. The skin that you're in has given you more problems than you can stand. As your waist line continues to grow, the more uncomfortable you feel when spending endless amounts of money on new attire.

Your life is constantly being compared to those things of a superficial stance. Societal influences within the most unrealistic way have become those which all your decisions are made. We've all been there. The point is – we must declare victory soon after we leave from such dreadful place. Unfortunately, we cannot and will not leave this place if there is no vehicle that can take us away. A form of transportation that can lead us out is one that is embedded within us-only. The dependency of others to taxi us off will never happen.

Individuals all over the world, regardless of ethnicity, social economic status, and even culture, share a common thread, which is to embark on the enhancements of beauty. Many times these individuals fall short of true gratification. The tendencies to do more is often motivated by influences. Fulfillment of happiness is inadequately discovered. Therefore, the goal to become more appealing is identified by congruent lessons of failure. On a more positive note – that failure does not have to be yours. Use your time more wisely with respect to those things of greater importance. Turn your focus from finding more ways to becoming more physically attractive toward the parts of you that are defined with a real everlasting beauty.

Discover you, the real person covered in make-up, disguised by extensions of hair, aligned with crimson colored products of fashion, and made whole by trendy assets of worthlessness. You are truly beautiful. Time is short and you want to enjoy it while you can. So, don't spend too much of it focusing on that which has no significance on Judgment Day.

When you discover true beauty within, it will prevail effortlessly.

Where to Find Me: in love with myself and all of my imperfections

Lovely, I am, 2009

Responsibility

Never allow your learning to interfere with your education

Violence and the lack of education have truly become issues that have negative induced effects on our world. Murders, deaths, and tragedies are so common in our society that we rarely take much notice to their occurrences. The news broadcast these illuminations of casualties without pause. Sometimes we turn the channel after hearing of such sad and emotional situation just to tune into another one with similarities and of greater volume. Nevertheless, our thoughts diminish with the click of a button.

The commonality of such circumstances takes on an unfortunate tone considering the outlook that many of us have regarding it. We don't truly recognize the importance of life and what it means to have such preciousness taken from us. Often, importance is not thought until tragedy runs full circle around us. When we, ourselves lose a loved one only then is the pain heartfelt.

Although we feel distanced from the many tragedies, for the most part, we are actually responsible! We may not have pulled the trigger, used the knife, or actually poisoned anyone, but we do and have played an important part in societies development. When we see a crime we hesitate to respond or contact proper officials. When children misbehave in our presence we ignore them and call them menacing rather than using progressive intervention. We don't take the necessary time to educate and raise our children.

If we even think for a moment, we may recall a time when we insulted someone meaninglessly. We may have called them stupid, ignored them, tore their feelings apart, insulted, or even played out what we considered an innocent joke, which had an everlasting and negative effect on them. All of these elements and more are for sure ways of tarnishing someone's social identity and their outlook and behaviors in times to come. We are the ones who stimulated these plagues upon them. We are the reasons why they've taken an inhumane turn on the world.

Let us accept our faults and uphold our responsibilities so that we can make positive change within those in our footsteps.

The differences to be made within our hopeful future lies in our hands. It is we who are to make them reality.

Where to Find Me: advancing in an environment where I will assume a greater role to becoming an advocate for a changed and progressive society

Looking Through Glass, 2009

Revelation

Endurance is a substance which impels growth

Riding around bobbing your head to pounding lyrics flowing from your dashboard speakers can often be a stimulating means of blocking out reality. For some time you have tried desperately to change your life for the better. The consumption of all things positive have become a part of your daily life through honest efforts. People greet you with great hospitality when you smile at them. Recognition has been extended to you at work for the success you've brought the organization. Your spouse and children are masked with an uncontrollable, joyful welcome each time you enter the house. You bring forth nothing but great energy to those around you.

But . . . there is another side of you that no one sees. You are at peace, but only externally to those of witness. No one sees the tremendous pain lurking inside of you. Awareness of your thoughts of suicide has never been a factor until today. Reality that you couldn't be more unhappy is merely a factor only recognized by you.

You are a faker in a sense. Don't be alarmed! You are only being dishonest to yourself and of course to those who care about you. Your inner structure is flooding with stress and is on the verge of a hyperventilating break-down. It is only relevant to a large part of your health. That part can be the difference between life and death. If you didn't recognize the sarcasm, it was briefly input.

But seriously, as you sit quietly in your world, imagine the words of an old gospel song dispensing caressing thoughts of divinity. Pay close attention to those lyrics of serenity. Take the message given and parallel it with those images of your life that you allow no one else to see.

Ask yourself "What is it that God is Requiring of me? Does God want me to have a faith based life where stress can be relieved?" Are your burdens those which can be relieved in comfort once you open up to him and ask him to relinquish them? Is the pain you hold on to worth self sacrifices – those of which brings forth constant pain?

Until you find the answers to the many, many questions in your head you shall continue to play hide and seek within yourself. Games are no fun when played alone, especially when you're losing! Dig deep within the trenches of yourself until you can touch even a small glimpse of purpose. It's there. Keep looking! Keep digging! Life is far from over for you. It has just begun.

Where to Find Me: within an enchanting song of solace where the rhythms are paralleled by peace and devotion

Of Bountiful, 2009

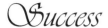Success

He who thinks he have all the answers is unaware of his own ignorance

Are you smiling right now? Well you should be because that is the one thing no one can take away from you. As a matter of fact, you should compel yourself with more of it!

There are so many wonderful things going for you. Success is staring you head on as it reaches out to grasp your hand. It seems like the world is open, free from any oppression that can plague you. Your walk has found its strength and now your ambition toward things in front of you are assisted with a little extra push. There is absolutely, positively no slowing you down. There is no looking back toward those things that lag behind. You are astonishing, a person of high endurance who is well on their way.

Now think for a moment. How did you arrive at such a fascinating place in life? What driving force guided you here along this pathway of passion and achievement? For a moment, a day and maybe even for a year, you have come to believe that your road was paved all by yourself. The fact is, you were never alone in this quest even when you didn't see anyone traveling beside you.

I got news for you. You had company! There are so many who guided your steps. So many who were behind you with their hand in your back.

Those before you who failed gave you hope and understanding to prevail. Those who fell short gave you the legs necessary to run. Those who lost their sight in the clouds of dust gave you the vision to see past the challenges that reached out at you. These are the individuals who humbly deny the credit for the many accomplishments which have soared into your impeccable life.

So, take a moment out of your busy day every now and again to remember the triumphant leaders in your life. If you know who they are and where they are send them a message in your own way and let them know that their efforts were never in vane. If you are unaware of their presiding, send out a prayer to them. God will deliver it.

Thank them – again – each time you smile

Where to Find Me: grateful beyond grateful

The Cross Over, 2009

Week 2

To understand the vision of control one must have the ability to witness clarity

Understanding

A faith holder cannot fail — It is a success to be one.

Every intimate relationship has its on set of satisfactory levels. For the most part we know of those things that have the ability to make our partners happier, as well as ourselves. They are too aware of the desires within us. Therefore, we often speak them rather than demonstrate. These verbal expressions have taken place on both ends and to some degree have been welcomed as abiding information, which pacify us.

To some degree quality time has become meaningless. It has gotten to the point where the *quality* description of it has little or no value. There is no affection, no desire and no compassion that gives one the sense of love. Our mere presence, less the engagement has become the definition of time spent. We are only near in the physical sense, but absent elsewhere.

If this is the case, what has happened in our relationships? Many of us have allowed interference to take a strong hold on our lives and it has become uncontrolling. We can't find the time that we use to have. Tending to the children has proven to be more challenging and consuming than ever thought. The new job, which is so demanding is so stressful and needing of our loyalty that we don't have time for those things of greater importance. We have begun to downplay each situation with a void.

Excuses are growing ramped. They have become expected and occur so often that our partners have learned to detect them before they are revealed. To grow in any relationship we must learn to prioritize. We have to salvage these relationships if we in fact want to continue them. There is a need for us and our time that we are too far away to notice.

Move in closer and engage in those things which will prove beneficial to you and your partner. Realize what is truly and undoubtedly important. Caress it with love and compassion, and it will soon blossom into that flower of promise.

Where to Find Me: spending time making those things of importance a need

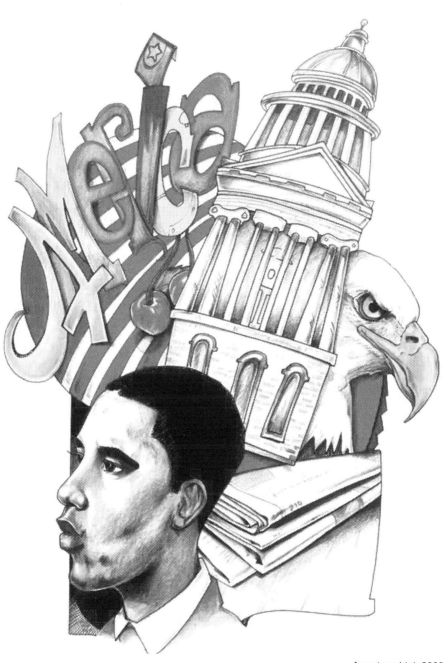

American Idol, 2009

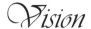
Vision

Everyday is a good day until you miss one

On December 29, 2008 I received a phone call at 2:07 p.m. It was my sister. She was calling to inform me that my great aunt Lucy had passed on. My heart dropped. A nervousness flowed through my body at that moment.

I realized that there was one thing that we can never prepare for no matter how strong we are, no matter how much money we may have or how much Christianity or faith we may hold. It was a thought as any revolution.

Saddened by the thought of losing a loved one is only overshadowed by actuality. Extreme difficulty will assume our minds and hearts as we encounter far unseen challenges that will soon follow. However, we must stay mindful that God is in control of all things. All of them! He hears the questions "why". For they flow to the heavens without hesitation, without breaks in between. Remember, he makes no mistakes in his choices. He makes no wrong moves in his steps.

Life is lived so that it can come to that selfish and unwanted end. It is and never has been meant to thrive here on earth for eternity. We all must follow that destiny of leaving behind all of those who will mourn our absence. It's our only and truest fate.

Yet, instead of contemplating on those moments, focus on the one which has your attention now – **right now**. The moment is here for us to let go of those senseless grudges. Time has come for us to forgive our brothers and sisters, our wives, husbands, and cousins. It is time to stop blaming our parents. It is time to look past that which once proved to be a disaster. The time is NOW!

Time allows us to enjoy those things forgotten. It gives us an understanding to the art of living, a small glimpse of the meaning of death. The teachings of it are far beyond anything comprehensible. However, it will end far too soon before we realize such.

As we reminisce on lost loved ones, let us simultaneously find it in our hearts to reach out to those who are still with us. Let's love, forgive, and assume our greatest responsibilities here on earth. Let us replace blame with love, sorrow with forgiveness, and selfishness with giving.

Rest peacefully Aunt Lucy. You have taught me one more lesson that will enhance living – to live life within the moments of happiness.

Where to Find Me: in this temporary place where I will love endlessly

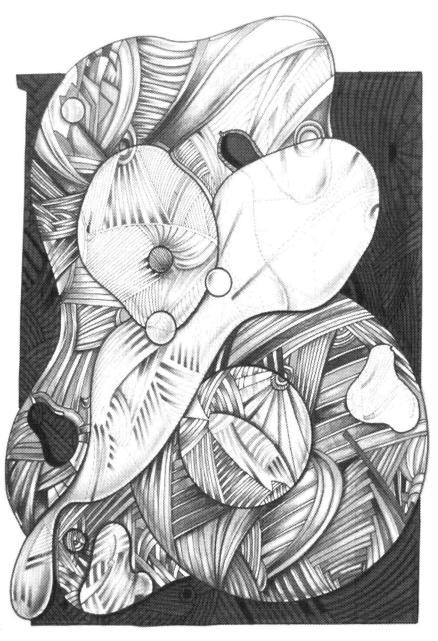

Hue of Heaven, 2009

Control

Control is not measured by one's strength, but by that which holds power

What is that one factor in life that we are really in control of?

That is simply a question which has to highly be evaluated in order to produce an effective and logical answer. On the down side of things, we allow many factors to take control over us. These things absorb the power that we thought we held. In many cases, there was no such power from the start.

For example, we allow a morning headache determine how our day will be. We allow individuals to inform us as to what works best for us. Each of us have once allowed a friend in our lives recommend something that proved to have worked miracles for them. They tried a diet and lost 12 pounds in a couple of weeks. They found love via the internet and now have set a wedding date.

I'm here to tell you that what works for one doesn't always work for everyone. The one thing that we have control over is so far embedded within us that we often really don't know where or how to search for it. *We don't control our thoughts*: they are controlled by influences. *We dont control our emotions:* they are random and constantly being expressed within those moments outside of our consciousness.

So, as you go out in search for control be open and willing to condemn all past judgments, for control is often only spoken of. True control may very well be a result of having ownership over something that no one else possesses. But the lingering question is this: "What do we have that no one else have?" Could it be our cars, homes, spouse, children, or money? NO! We have complete control over none of those things. The only thing we could possibly have control over is ourselves and how we adjust and relate to decision making. Even that's questionable.

To have control one must have a natural instinct to be open-minded. One must be willing to accept ALL possibilities regardless of how strong surrounding influences may be. One must hold prejudices and judgment of no man without truly knowing him. To acquire the privilege of being in control of anything one has to undoubtedly obtain a vast array of confidence in self. For the most part having control in total is not a likely thing. However, within highly reasonable factors it can be assimilated.

Remember, at all times, that in order to possess self-control we must discover what's controlling us.

Where to Find Me: trying to stabilize those out of control constituents in my life so that I may gain a better understanding of them

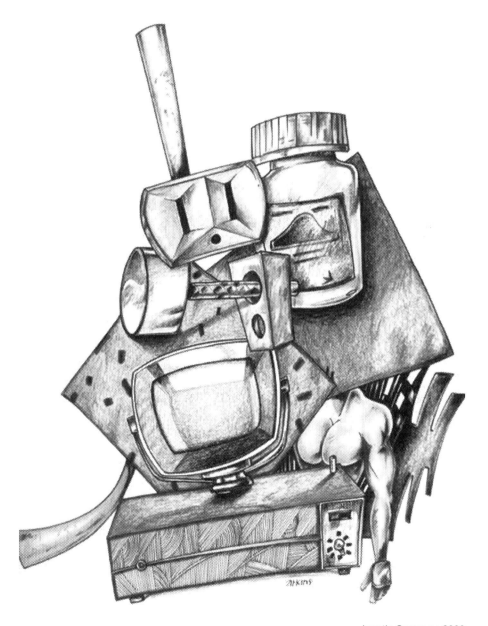

Input's Currency, 2009

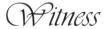itness

Allow your religion to be more of a love affair and less a conversation

There's much more to being a witness than to see who started a fight, or to have heard the negative remark that Kim said about Tiffanye. Yes, being an observer entails insight into particulars.

Consider yourself and those things that you have allowed to interfere with your happiness. When and if you really and truly take the time to focus on this particular aspect of life you begin to notice things. One is that your life has taken and continues to take on some meaningless and unnecessary natures, a lot of which you could definitely live without. For some time you've wondered and asked yourself about a plan to dismiss all of these worthless aspects. However, no clear methods for doing so have surfaced, at least none that you were willing to address head on.

What you may want to try is removing yourself from standard and habitual ways of thinking. You already see that there is no relief in your contentment. Not only should you be a witness of things past, but also of things to come. In order to consummate this effort your desire to accomplish has to be motivated by willingness. Your desire to make progressive change has to be a self made decision with no excusable interruptions.

HAVE FAITH IN YOURSELF THAT YOU WILL MOVE OUT OF YOUR OWN WAY.

Where to Find Me: in dismissal of that stuttered walk that has placed me further away from happiness

Looking For Chance, 2009

Clarity

Life is shorter when unhappiness controls it

You are truly living in an unfortunate situation. The problem is that you don't know what to do to get out of it. You are holding a grudge on someone for some particular reason that is majority an assumption. The hatred which has developed in your heart is not only without true merit, but also fueled by far-out thoughts of senselessness. These ideas have undoubtedly become health-hazardous. In fact, they have taken over a part of you. Very little is to be gained from the thoughts of these continuous flashes. You have no control over your emotions. You have been weakened by an element that holds no true validity other than obscured speculation. As your life has grasped onto these mere images, which run through your consciousness without warning, you have attempted to win the battle. However, you are unaware of who you are up against.

So, as soon as the field illumes with a small glimpse of clarity, the enemy resurfaces and forces you back into a defensive position. You can win this war against those things that haunt you. You must develop a plan to conquer. Start by addressing the circumstance head on. Within deep evaluation learn of the situation from its core rather its exterior façade. Only then will you discover the source of your anger. All that you ever thought to have known about this situation may prove to be the total opposite. The part you didn't consider. Allow yourself time to comprehend this doubting information. It may very well prove to be your gain. You owe it to yourself to be freed from the chains that bound you.

Life is like a car. Be careful where you go in it. It is in fact too short of a distance to run. Take your time and enjoy the travel while you can because soon, very soon you will reach that undesirable END.

Where to Find Me: on the other side of anger where pleasantness roams freely

Running Of Dirty Waters, 2009

Week 3

Selfish enrichment may detour a peaceful death

Selfishness

It's possible to succeed at failure

There are many of us who have the sinewy desire to be over achievers. We live for excellence. We strive for greatness. There is absolutely no tolerance for those things that have the will or power to slow us down. Our momentum is fueled by an accelerated lust for perfection. Acceptance of anything beneath the best is not tolerated nor is it welcomed. We desire to succeed by any means.

This is an addiction!

There is and never has been anything wrong with rising above the threshold of the gates which have been opened to us. But at what cost will we travel through those gates?

Just for a moment, right now take a good look at your surroundings. What do you see? Do you see the results of your hard work? Are you fenced by things of great value? Are the benefits which you've received impressing? Well, maybe you have made it. Maybe your success is everyone's dream. Then again, maybe it's not.

The sad part about many accomplishments is that some are made at the expense of others. Sometimes we get so caught up in reaching those potential goals that we seldom take time to see the neglect along the way. Many times, in the midst of it all, we lose our spouses. Our friends don't bother to come around or call anymore. We find ourselves in a state of loneliness. Brothers and sisters have found themselves as outcasts and no longer feel worthy or accepted. We totally shut ourselves out from the world. We don't even notice our children's growth.

Now, can you see success from a different angle? If not, look closer. It is time to reflect on that of greater importance. Too much time has gone by since we really and truly felt blissful and unconditional happiness. Too much time has passed since we spoke to an old friend, called a family member, or even given time to something other than ourselves. We haven't even told our children that we love them!

Now is the time to live peacefully without all the hustle and bustle. Set aside the thoughts of achieving more and turn attentions toward thinking less selfishly. It is time for humility to find us. It is time to be humble. It is time to live free from selfishness and hurtful neglect. Open your eyes and see just what your success has done. What deprivations it has permitted. Your adaptation to it has not only shut you off from the rest of the world, but has also caused you to think within a small frame that lacks happiness.

Realize that success is no good alone. True happiness must compliment it.

Where to Find Me: making valuable time for those that I love and those that need me

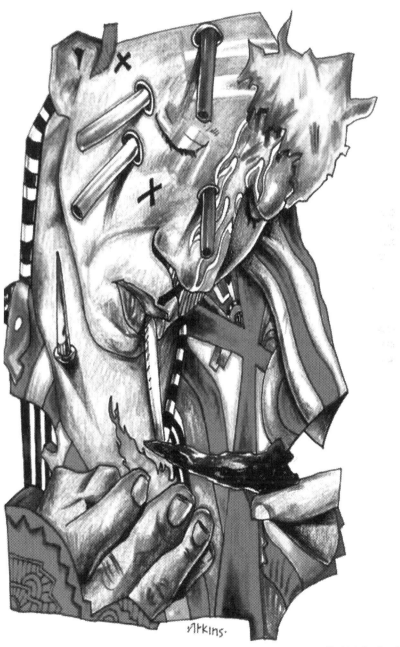

It's Not Caviar, 2009

Enrichment

Each great structure must obtain a strong foundation

Each of us have heard the phrase "what goes around comes around." Unfortunately, the day will come when that will prove to be true in each of our lives. If we could pin-point the place and time or even make somewhat of a plan to cope with the unraveling of the situation we could then make preparations to cope. We could even make preparations to suffer the fall.

Well, too bad! There's nothing that we can do to alter this inevitable action which will soon develop within our lives. It's not that we deserve to experience Karma, it's simply what life tells us to expect. Therefore, with expectation comes action.

For example: Have you ever been speeding in your car openly, freely, seemingly without a care in the world?

You only have if you drive. In the back of your mind you knew that you had a 50/50 chance of getting into an accident. None of that really mattered too much to you at that instance though. You knew of the consequences, but didn't care. That is exactly how we maneuver in our daily living. We speed through life, make horrible choices, and all the while we recognize the consequences of liability. We are already aware of the aftermath that could possibly take place as a result of our doings, but do little to redirect. So, is it safe to say that we do these things because we are stupid or because we allow ourselves to think that we can get away with them without one day taking ownership. Either we are stupid or we could opt for an euphemism which doesn't sound as appalling. Take your pick.

Simply, however difficult, we have to take ownership of a circumstance that could possibly foster in the revelation of something not sought after. It is up to us individually to really "think " and be aware of how things may come back to haunt us if we take a certain action.

And while you're thinking about that also consider reevaluations.

WHAT WILL HAPPEN:

-If I cheat on my spouse
-If I steal that shirt off the rack
-If I lose my temper and hurt someone
-If I confront a person without solid grounds to do so
-If I cheat on that test
-If I blame him for another man's child
-If I blame her for my suicide attempts

Where to Find Me: attentively being conscious of the decisions I make

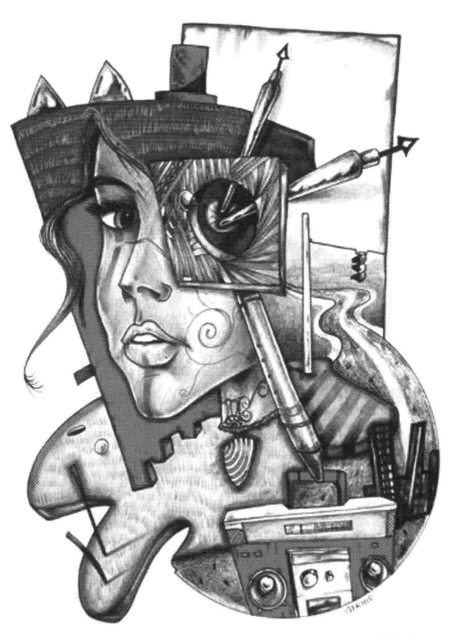

Looking for Sight, 2009

Peace

Never allow a lost individual give you directions

The time has arrived for you to stop dead in your tracks, look back within the airy space and count all that you've been blessed with. Some time has passed since you were appreciative of those things you have. Days have gone by, even years since you truly were in tune with the elements around you that make you happy. Besides living in the grace of good health and surroundings of those you love, you have had the opportunity to live the most lavish lifestyle. Everyone who visits you stand in awe of your spectacular splendor of possessions, exceptional belongings that align your closets of massiveness, and the finely tuned mechanics that you hardly find time to enjoy. Your persona has become unmistakably that of class, at its peek.

Who are you really? You are not that individual that everyone notices when they walk past you in the shopping mall. You are not that person you portray to be when you're out with friends pulling up to valet. **No!** There is much more to you than can be seen by the eye. You are filled with helplessness and pain. There's no one whom to discuss these concerning issues with because your true self is too ashamed of what opinions may come. And yes, if they actually knew of how you were really living "they" would laugh with applause. An awkwardness of envy would travel in your direction once you were recognized.

Instead of going about your daily tasks in hopes of gaining the attention that you want for yourself from others, find a new way of loving you! You were never that popular in High School and you don't have to be now.

So, stop wanting for attention driven by childhood fantasies. You're an adult now. Discontinue these antics of your altered ego and focus on the reality that lies deep down inside. It is who you are and who you really should want to be known as.

Each of us have probably become familiar with the phrase "God grivet and God taketh away." That not only holds truth to those things of materialistic nature, but also those things regarding friendships. We don't have to hide ourselves from true friends. They don't want to see us fail no matter how far behind they feel they may be. You see . . . God knows this and he constantly places people in our lives each and every given moment. For a specific reason, I might add. That reason may be of reason or it may not.

It's past time to shut the door on those things of little importance and open one up to a newness that allows us to be free to be that which we really are.

Where to Find Me: in real life, standing beyond the curtains of camouflage

Empty Holes, 2009

Death

Life is only a breath

A small piece of soap sits inside your bathroom shower on a dish. You reach for it hesitantly as you look around for a bar with greater volume. Unfortunately, the minute portion is all that you have. There's nothing worse than trying to hold a small piece of soap that keeps slipping from our hand. It's annoying and irritating.

In comparison it is exactly the way our lives are. We only have left what we have not used. In time, melting will occur as the strong, aggressive currents of life gradually diminish it. Therefore, preservation is something that we must approach passionately. Soon, that small portion of life will slip from our grasp, fall into the welcoming drainage and be dissolved forever.

So, consider the time you spend. Make an honest effort to use it as a benefit. Ultimately, this benefit should cater to those of importance. Stray away from those things of little value.

Take time to appreciate life while opportunity allows. Do whatever is necessary for you to end with a peaceful goodbye.

Where to Find Me: lathered up in life with fresh ideas that will help me soar to my greatest potential before I melt away

Life's Full Length, 2009

Detour

Never depend only on the limits of self understanding

Is your greatest fear dying or is it based on something with more monetary challenges? To cope with life's consistent ups and downs truly takes some personal commitment. Many of us get so caught up into the ease of life that we can't deal with the tuff challenges in our wake. We assume steps that guide us far away from our divine holdings that once proved to be true. When times get difficult we close ourselves off from the world. We open the doors only to those things which hold a lesser meaning.

I sat in a hospital for 3 hours one day. It was an emergency room located near the Critical Unit. Almost everyone in the waiting area was consumed with something greater than I could ever fathom. A little boy ran through the area with a small truck in his hand. He smiled, but I could still see the agony of his pain, which the cancer in his body projected. He bumped into a large gentleman who weighed about 540 pounds. He had lost one of his legs to diabetes. Alongside him on the same side of the room stood a woman. She rifted off into space, looking at nothing in particular. Tears delicately streamed from her eyes as her body ached from her last surgery.

After a short while the little boy's momentum halted. He sat down beside his worrying mother as she comforted him. She must have known that her son only had a few more months to live. Out of the doorway a young girl sprang out frantically. The news that she had just received devastated her to the brink. She had just gotten her blood tests results. I sat boggled within the tiny corner of emptiness. Sheltering myself from imagination.

Now, ask yourself, how important are those small problems in your life by comparison. Like that jammed finger, which took me to the hospital that day. You have something so precious, something that those in the Critical Unit see each day fade from their grasp. You have life, good health, and tomorrow to look forward to. Reevaluate the circumstances in your world. Discover what's truly important. Change the situations that you may and forget about all those of little meaning. The guarantees of life are dwindling each moment of breath. So, act sooner than later to accommodate and shelter life's worth.

Look at life and health in a greater way. It is indeed the only one you'll ever have.

Where to Find Me: over there, engaged in better decisions that will bring forth longevity, indulgence, and life

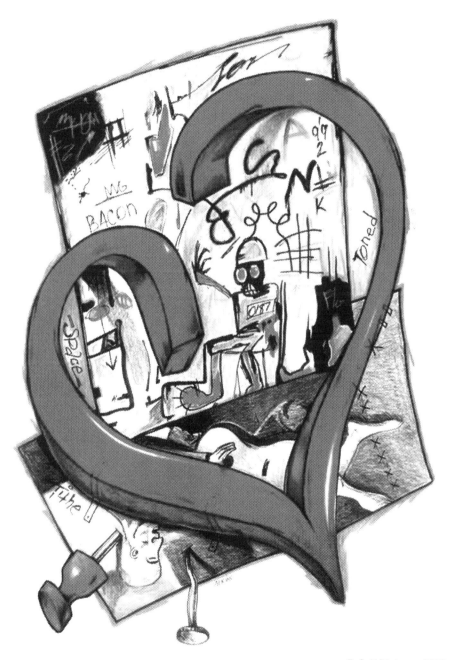

P. S. With Love, 2009

Week 4

The content of words have the greatest momentum
when they're committed to substance

Contentment

Sometimes desire is greater than ability

At some point in our lives we have to sit back and take a deep breath just before taking that big stand. The cycle has finally emerged for us to move toward that goal, which we doubtfully see in the distance. Realize that it's more than a dream – it is a dream deferred, one that has to be dealt with. Putting this off serves no purpose that can be made beneficial. To not address them only creates more confusion and more willingness to ignore.

There is an intrinsic desire that contrasts every doubt you may have. Deep down inside you want to take the first climb, but your attempts fall short as the doubts within place your feet back onto that flat surface. The assumption that you lack ability has consumed you. This factor has to be released. It must find its end. There's no way to move without trying. Pivoting only takes you so far. You must dribble the ball closer toward the goal if you want to make the basket.

Excuses are what you've become most accustomed to. They have become your strong points. They are such a part of you that you've almost named yourself after them. When those around you see you coming they most likely say "Oh no, here comes Excuses." Your energy is so draining!

People closest to you have tried to be your shield of comfort, but the constant self doubting that you express has enabled them to find free will of their own. You are becoming a casualty, one that everyone wants to avoid. The negative energy that you give off transcends into the spirit of everyone. Yet, it is not desirable.

Move the excuses from your life and replace them with positive confidence. Not only will you begin to see the attractiveness of individuals, but also an attractive portfolio in life's achievements. There is absolutely, positively no way to progress if you are at a stand still. Move around and accomplish.

Where to Find Me: in a confident capacity where goals will be met and gains, embraced

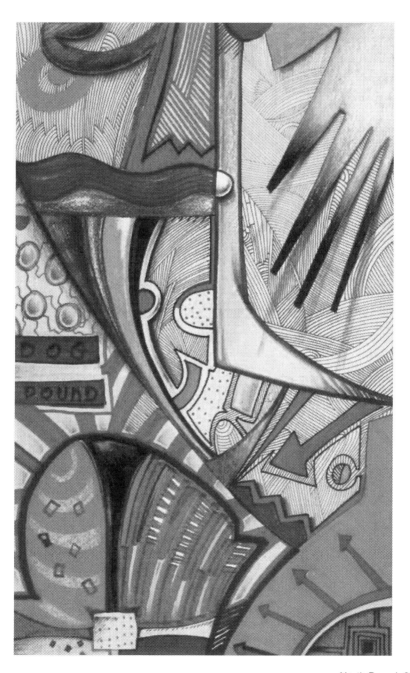

North Bound, 2009

Words

Words are meaningless and week if there's no substance behind the source

The word of a man once was taken as that of gold, that of divine truth. But a lot has changed since then. Now, words have become weaker than the strength of a pinkie finger. We all know of one person who is always talking, always proclaiming to be more than reasonable possibilities will allow. We accept them because they are merely a source of good humor. Any merit that they once held has diminished into the thinning air.

We ourselves tell a little lie every now and then. We do this to be impressionable or to disguise the truth, altering one's opinion of such. Some of us have just gotten to a point in life where lying is a rude habit, one that we no longer have conscious awareness of. We lie about the weather, lie about the car we drive, lie about the house we live in, lie about the money we make, and lie about our relationship status. We lie so much that "It Ain't Shit To Tell A Lie!"

Unfortunately, these untruths in our world have a much greater impact on us because the lies we tell are only as strong as the truth that lurks beneath it. If the lie is large, then the truth is probably even greater!

For example, when a person tells a lie about something as simple as the city in which they grew up in it actually tells a lot about that person. It illustrates how small of a mind they really have. It shows the lack of pride and the longing to be viewed as something more spectacular. The close mindedness has plagued such person within a derogatory state where social acceptance has stunted personal grown. Therefore, the mere illusion of being something more gives them a sense of belonging. The sad part is . . . no one really has any concern about such mild things which would even make a bit of difference.

So, just before we tell a lie let us rethink the situation and impose an alternative that if not the whole truth, one closer to it. Lies foster the birth of other lies, which creates the burden of continuation. To live life in a lie is to live life in darkness. Let us not live out of reach from that reality which helped develop us into who we've become, rather let us embrace such truths so that we may continue to climb upward towards all that is meant to be reached.

Where to Find Me: further form dishonesty and closer to the truth

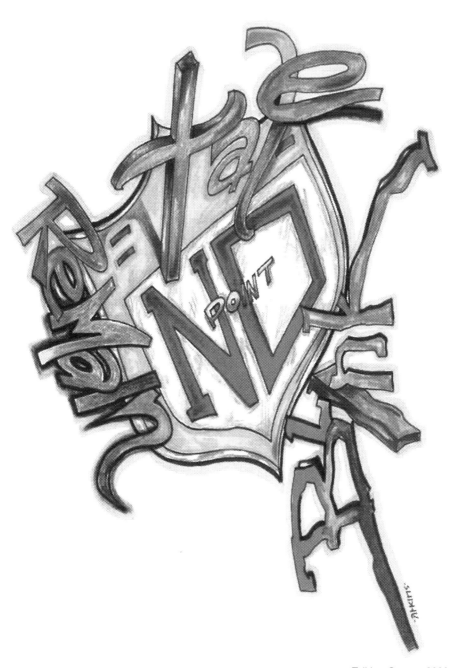

Talking Games, 2009

Momentum

There is no value in self pity and no gain in sorrow

I recognize you from far distance. Your walk is a familiar one. The bowed head, eyes affixed to the ground which you walk upon, the slump in your back, and the weakening somber which reeks from your presence, are all characteristics of the "I'm a failure syndrome." Your confidence and feelings of worth have been shattered by no other means than financial. In the past, life was good to you – even great. From a societal view point. You had it all – the home, the cars, the friends, the American Dream. But it all evaporated within a blink of an eye. And now your livelihood has been compromised. Tampered with. Your standards are no longer scaled within a fraction of success. You feel as though you are dead and nonexisting to the world and to yourself.

Well, just like you have been told before, I am giving you confirmation . . . It is time for you to get out of this slump, move past and beyond that undesired boundary of circumstance, and uphold that small piece of hope that wakes you up each day.

It may not sound like you have much left to live for, but in actuality you indeed have all the necessary sources to begin anew. Take a good look at yourself and your family around you. That dependency that you see lies upon you. No one else. Your engrossed demeanor will cause them to take hold of the same negative outlook on life. Your walk will become theirs. Your depression will conquer them. It's the season for you to get back up and get back at it. Discontinue looking toward the empty pools of disgrace, sorrow, disgust, and painfulness. It's time to move toward a larger body of water that flows widely with potential, hope, desire, and ambition.

Use what you've lost as a foundation on which to build your new gains. *Life isn't over!* No matter your age, it is beginning again – right here. Right now. Hold your bowed head up high so that you may see farther into a positive distance. Allow the sun to burn your eyes. Straighten your back and relieve the tensions of pain which lurks behind you. Refresh yourself so that you may refresh your ideas of approaching a total success that awaits. It's time to change your walk! It's time to run!

Where to Find Me: moving with greater confidence toward the pool of second chances, swimming upstream towards the success which I haven't found

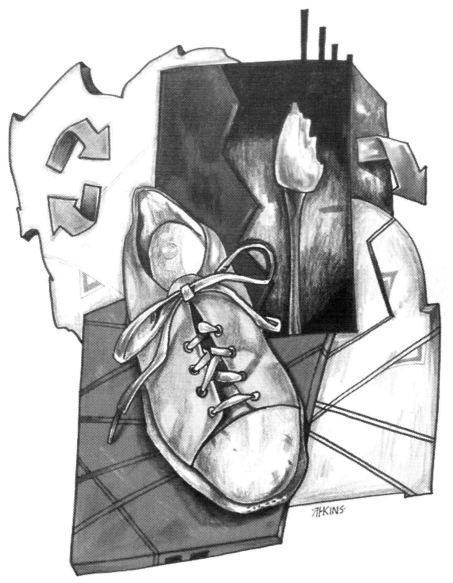

Far Walk No More, 2009

Commitment

When you think you're the best at something you've had little competition

Marriage can be one of the most beautiful infusions that two individuals could ever bestow upon each other. It's adorable from many aspects of consecration. It comes upon us in the most desirable times in which to make claim for the impressionable. However, marriage is becoming more and more that of lesser value. The terms and conditions of such contract have fallen to an all-time low. In many ways it has become an act, which often serves the purpose for materialistic acquirements or the "two incomes are better than one" syndrome. In many cases, women are the aggressor when it comes to readiness. They seemingly know and understand what they want sooner than men. On the other hand, men have to often be pushed and persuaded. We have to be shown what we could miss out on if the ultimate commitment is not sought or fulfilled.

When a woman marries a man who's truly not ready she will get a man who is **truly not ready**, thus the life span of that particular marriage becomes contingent upon how quickly he can grow into the ideal and conform to readiness. Nevertheless, men should always keep in mind that women won't wait forever, nor should they.

No matter which side of the minister you one day may stand, take your time in such decision making. If it is truly meant for you marriage will come to pass within minimal expectation and effort. Just the same, upon forces of the natural which constitutes unreadiness and unwillingness to commit fully, it can also come to pass, but likely will soon end with the greatest expectation and effort.

Have especially high regards toward marriage, for it is a special bond where love should prosper and loving things within it shall gloom even in the dimmest light.

Where to Find Me: becoming one with myself so that I may share that experience with someone special in the most Godly fashion

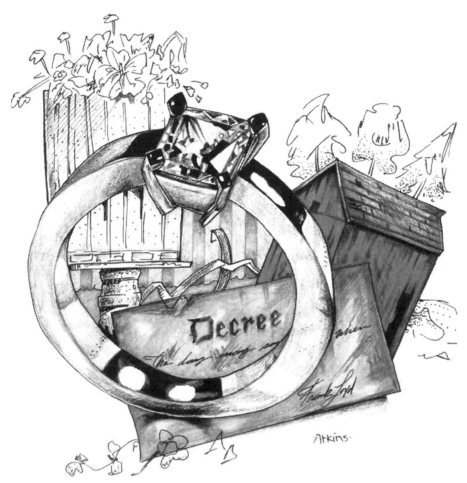

With This Ring . . . , 2009

Substance

Greed tends to overwhelm the soul

Imagine life as a food buffet. So, many options to choose from that one may not always make the wisest selection. The fried foods are always the portions that gain greatest attention. However, they are cooked in a substance that is likely to cause problems in our health and inaccurate decision making. We find difficulty avoiding the golden crusted portions which have been sweltered in a sea of oil and fat.

Next to the green salad of chaos is the seafood. It has been baked and broiled to an edible perfection with limitless bottoms of consumption. Here, your life will change due to the lies, unfaithfulness, and staggered ultimatums that you engross in.

just a few feet away is the desert bar. Undoubtedly, it is most inviting. Everything looks tempting. The double layered chocolate cake, and fresh vanilla bean ice cream are all optional. They are displayed as beautiful crossed legs, endless beauty, adorable abs, and all which gains lust. We are encouraged to taste of the melons outside the gardens of our spouse. We yurn to drink and sip from the picture which is poured by strangers of the sweetest endearment.

With the consumption of many of these items our lives may fall short from all that God has planned. It is very important that we control our diets of life.

Where to Find Me: at the table of life choosing the best selections which may foster a more gratifying appetite to do what is in my best interests

Influence Over Need, 2009

Week 5

Disparity brings forth pain as convictions of worry exiles distress

Disparity

The mind never rests, neither should determination

Stop! Relax! Kick your feet up and empty your mind of all your daily obsessions. Your mind has been so cluttered that stress of accomplishment has become integrated within decision making. As a matter of fact, stress has become such a part of your life that you probably wouldn't feel as productive without it. Not only has the dependency upon stress caused you to feel a small inclination of achievement, but it has awkwardly become a need.

Unfortunately, you are so far gone that you don't realize the affects that your life has gained because of this. You have welcomed compulsiveness and closed the door on God. Without a certain level of stress you feel as though you are not moving fast enough toward your mark. Strangely, you have a high comfort level when burdens are present. Without them you feel unproductive, lazy, and a sense of insignificance.

Eliminating that which is causing you stress may indeed prove to be highly beneficial. But you must be willing through a self-desired discipline. You will more likely reach your goal more effortlessly and within a more durable time frame. Stress can be presented in many forms. Actually knowing the cause of it can prove to be the first step toward relief. However, if it is more complicated than you can handle you must turn to God and allow him to deliver you from it. This must and can only be done through a faith-based belief that God can and will truly be of deliverance.

Attempt to succeed minus those elements that potentially hold you back. Regardless of what you believe, there is actually more for you to gain without the elements of stress.

Continue on that road to success in a more peaceful travel without unnecessary boundaries of urgency.

Where to Find Me: on a stress-free path to accomplishment with God as my guide

Yielding Pain, 2009

Pain

Anxiety is to grief what inferiority is to worthlessness

One of the easiest ways to describe pain is that throbbing sensation that you feel deep inside your knee. Each time you stand or walk the pain intensely pokes at you, causing the evidence of such turmoil to mask your face.

But what about that soreness in your heart that causes you to close the door on life. It is the reason why your attitude has changed so drastically. No longer do you want to be bothered by family visits or casual conversations with neighbors. Dating and meeting people have become almost as obsolete as a VCR. You don't want to go out and do anything that involves social interactions. You've allowed a devastating circumstance to create a sweltering shelter around you – one that has housed a painful hatred to the outside world. The agenda, which you have presented to yourself is aimed at meeting no one's expectations. The sad fact is that your very own expectations are included in this dilemma.

Sit down, turn off that television and write yourself a letter. Describe the feelings that have been swimming up stream within your tainted waters. Explain them as if you had only one letter left to write within your time on earth. Write the letter to all those who have inflicted pain upon you even if you have no intentions of delivering it to them.

This will be the beginning of eliminating that pain. You desperately owe this to yourself. Here you may realize that those things that have troubled you for so long really are not worth the time you put towards holding on to them. Those things may very well prove to be as vague as the memory of your kindergarten Principal. It is the pain that you hate, not those you blame for it. Move away from aversions that hold no true effectiveness.

Smile again as you lift yourself to a new height where pain is not heard, felt, or thought.

Where to Find Me: painless in a zone that is tangible, liberating, and accepting of new ideas

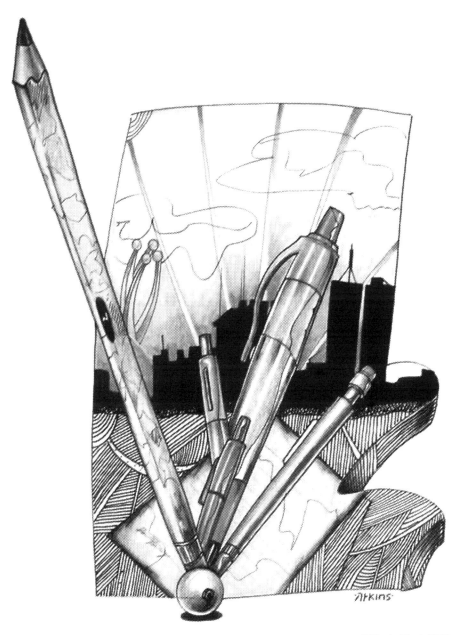

Writer's Pivot, 2009

Conviction

Pride is accomplishment's greatest reward

Your body's tensed, your heart aches, and your soul has been beaten by the burdens that are against you. The confusion in your head constantly tells you that things will never get any better. You've lost your job, your home, and your marriage is in total ruins – becoming second to a bowl of ice cream. Your weight constantly rises causing embarrassment even when you are the only one looking at the scale. You feel helpless, alone, and like a complete failure.

Fortunately, these circumstances are not only a test of faith, but they too are revelations ready to be unfolded. The time has come for you to take a stand against yourself and those things which confine you. The time has come for you to move past, beyond that threshold of comfort and open your mind to a freedom that you have been so afraid to welcome in.

Take an immediate stance in your life. Finally discover those things which are most meaningful to you. Move towards the elimination of stress by moving toward what really brings you happiness. Discover meaningful ways to break free of that job which holds you in a tolerable captivity and has for so many years. Opportunity has presented itself for you to fulfill your dreams. Walk past that mirror that makes you unhappy with yourself. Compel yourself with a methodical plan which will ensure more happiness within your own skin. Rethink and reevaluate that broken marriage that has proven time and time again to be irreparable. Make a pledge to detach from those things that bound you in a pool of heartache. It is time to look stress head on and conquer its army of helplessness.

Where to Find Me: in a world of newness, a place where love is on my side waiting for me to develop my actions into those things that only hold rewards of greatness

Never Endings, 2009

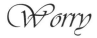

Worry

Change those things you can, forget everything else

DAMN! . . . Do you find yourself yelling that word often? Every now and then it bounces around on the tongue of many of us. There is so much going on in our lives that we can't find a flow of good air. There is no time to do those important and meaningful things. We can't seem to shake off those temptations of wrongfulness. We are constantly talking, but there is no one listening. People at work can't seem to understand that we actually need a break. Children are screaming, yelling, and running through the house none stop. The phone constantly rings off the hook. The solicitors are calling at 8:00 a.m. in the morning on your days off. Your mate is constantly nagging you for more quality time. Your money is funny to the point where your bills have become delinquent. Nothing is seemingly going right for you. Your pants don't fit anymore. Stressful circumstances has caused you to gain weight. You have little time for yourself, let alone anyone else. The one consistent question in your head is "What do I do?"

Well, it is time for a mental break, as well as a physical one. Seemingly, the world around you has caved in and the depths of it have smashed against your body causing intolerable headaches and soreness in your body.

The discovery of a place of peace is the one desire that seems so far out of reach for you. That place is much closer than you know. It is upon you. You just haven't recognized it yet. Look closer and you'll see it. But first you must move away from those things that challenge your attention.

Place the necessary emphasis on those things that have the greatest effect on your life. Spend time with your mate. Take that needed vacation from your job. Work on doing the right thing, instead of being weakened by temptations. Change your diet and work out even if it's walking once a week. Assume control of your life. Stop allowing the interventions of stressful things consummate you. Realize that many of your problems can be dealt with by yourself. There is no need to redirect these efforts elsewhere. They are yours to keep if you want them and they are yours to rid if you so desire.

Where to Find Me: discovering ways to cope with life's stress and attempting to find ways to lesson them

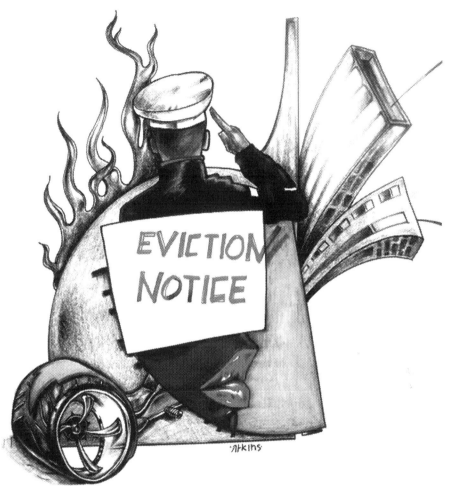

Mount Quell, 2009

Distress

Closed-mindedness has no outlet when it's closed

Man, life has dealt you a hand that you can't handle. You have been heartbroken. Just when you thought you had found The One you really found Another One! A complete and total idiot would be a more accurate way to describe this person.

Remember in the beginning when everything was going better than you could have ever imagined? The times spent at dinners were the absolute best. During that time you really developed a flow of communication which was seemingly ideal, one which fit so perfectly within your life. You opened up and shared secrets. You let your guards down in attempt to be self confident. Self sufficient. There were no inclinations that this person was a fraud. There were no signs that the person was actually living a double life, pretending to be all that you wished for.

Well, the ugly truth is simple. You have been played. Manipulation blinded your sight from the person hiding behind that stranger whom you began to fall in love with.

Although devastation has taken control of your world you still have so much inside of you. Love is what you give and it will soon be welcomed for what it is. As difficult as it may be for you to move forward and get on with your wonderful life, you must. Your strength is amazing. You are beautiful, talented, and intelligent. And oh so worthy of something greater than what you thought you had. The fact is, you had nothing! Anyone who lives within a persona characterized by dishonest means is only a fake. A fraud. A lie. Deception. Those things don't deserve your tears, your heartaches, your time of thought. Those things don't deserve your love or even a tiny portion of it. So, stand tall. Wipe away all memories of such undesirable circumstances. It is time for you to live for you and live with your very own interests in mind. Stop putting yourself second, third, and even last. Up front is where you belong.

Difficult times may come within the process of growth, but you can and will achieve it. The strong nature embedded within you is only a small fraction of who you are. You are a conqueror, one who shall look ahead with confidence and new found wisdom. You'll be better than ever. You'll discover genuine happiness within. Most importantly, you will look back at this experience and be grateful that it happened because it will have taught you of your deepest expectations and dreams. God will be your strength . . . Forever.

Where to Find Me: at peace with myself and far away from longings of false love

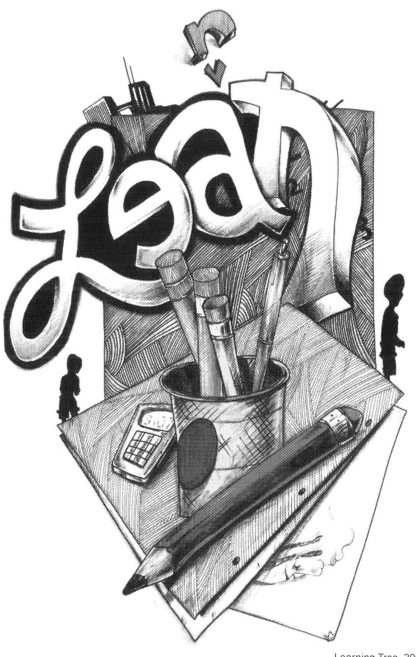

Learning Tree, 2009

Week 6

*The freedom to be honest is a measure
of independent achievement*

Freedom

Unbound by the chains of life are the living

Exhale! Stop feeling guilty about that which you had no absolute control over. Rewind briefly, that day in your mind and realize that it was not your fault. You have assumed the responsibility of the outcome. Yet, that choice has placed massive burdens upon you. The thought of it leaves you helplessly in a state of depression where vague glimpses of death have embarked on your soul. But what you have failed to realize for so long is that the circumstance which has proven to be fated was going to happen anyway. Why? It was the will of God, the controller of all things grand or small.

At some point we all have placed blame upon our shoulders just to be weighed down unnecessarily. We do this to ourselves more times than a few. Engagement, we find in this each and everyday for the sake of having ownership over something. However, guilt is the one thing that we find difficulty in as it pertains to self-forgiveness.

In this case, real time to ourselves is sometimes an essential need. We should break from the fast surroundings that keeps us from moving around the fact that we are only one person – a simple human being who is bound to make mistakes.

Cease the thoughts of your inane & self inflicted turmoil and begin a fresh start that entails understanding. Eliminate those meaningless ideas that have cast you into a world where shame has taken over. Learn to love who you are and what you have become. The sooner you realize that perfection Is the one stock which you'll never fully own, the more agility running through you will focus your attentions on those things of value.

Where to Find Me: on the one side of guilt where I am living free from worry. I will no longer assume responsibility for those things which I hold no control

Casual Ending, Emancipation, 2009

Honesty

Revelations of new things are not always of good portion

Avoidance has become a passion . . . Are you certain that you really want to know the truth? You must because you continue to ask for it. You are at a point where your mind is racing for answers. Although you seemingly need the truth to set you at ease it may indeed not be the best option for you right now.

Throughout life you've always wondered about that one thing that you felt would be a burden lifter once clarity was presented. On the other hand, you have had feelings embedded within you – deep inside – that alarmed you of the consequences that would have to be faced once you learned of the untold. And now the emotional thoughts of finding that desired clarity have returned.

The truth and condition of this burden may indeed open something within you that may help you move past that static state in which you nest. Although this is an important factor, you must consider all things that will come with it.

Knowing the truth may have irreversible effects on your life as well as the people closest to you.

For example: Does a man really want to know if that child whom he has grown to love endlessly is really his, when it's not? Does someone really want to know of the family secrets which once caused their loved one to experience tragic heartache, which ultimately led to their deaths? Would you really want to know that your deceased spouse for 20 years had been sleeping with your brother?

Maybe you would want to know that you have cancer and you only have 26 days left to live. *I think not!* Life as you know it will come to a screeching halt as you worry yourself in agony.

So with that in mind, make a diligent and wise decision and consider how your life may change once the truth is revealed to you. If it's something that you think you can handle, then do it. If the truth will most likely become an addition to your already miserable life – avoid IT by all means. It is not worth knowing.

Don't be against truth discovery, but do consider which time frame would be most beneficial for you in seeking this endeavor.

Where to Find Me – in a decision making process where I can comfortably seek understanding of that which holds me from knowing

The Picture Within, 2009

Measure

Take time to find yourself or be lost forever

Do you ever sit and wonder how life would be if you were someone else? We all have to a certain point. Thoughts of being another person may not have been taken in the regards of actually being them, but acquiring what they have has definitely crossed our minds. So, it's safe to say you wanted to wear their shoes and see how they would fit.

Admiration has consumed us in the sense that we have almost and totally created an unhappiness within ourselves. We often frown on who we are and what we've become. Our plots to succeed beyond that which we have gained have somehow taken a turn down a different road. A path we didn't follow. Instead, we have traveled to a destiny that we feel is beneath our creativity and less than what we once considered real.

So, we deal with this in a way that is somewhat surreal. We imagine through constant complaints that we are someone else. We are the person with the elaborate lifestyle which allows us to acquire the fanciful gains of life through a materialistic sense. We desire the celebration that we often see as beneficial gain. Unhappy is what we are for who we are. We have accepted the notion that life is not fair and has not been for us.

We ask ourselves and God "why". Why is constant stress building in my life? Why can't I get ahead? Why have my dreams fallen short of reality? Why am I Not Worthy?

These questions in our minds have not only caused us to live in a sense of inferiority, but also live as victims within our skin. Unfortunately, we sometimes get so aroused by what society has made seemingly important that we are reluctant to even consider those parts of life that are not.

So many WHYS consume us. But do we often consider the other side of "why"? The other side where deprivation doesn't really factor into our perception. From now on reconsider and look closer at those lost answers. Soon, your diminished way of examining your life may change. Attempt to understand a new aspect of "why". Why am I still here? Why am I not in a hospital fighting for my life? Why do I have a warm place to lie down and a hot meal to eat? Why do I have family and friends who love me? Why have I been given a second chance at life to make better decisions, to forgive, and make meaningful progress? Why has God not given up on me?

The sooner we understand why we are asking the questions "why" the sooner our stand in the world will be that of gratitude.

Where to Find Me: in an attempt to find those answers which will give my life the greatest intent

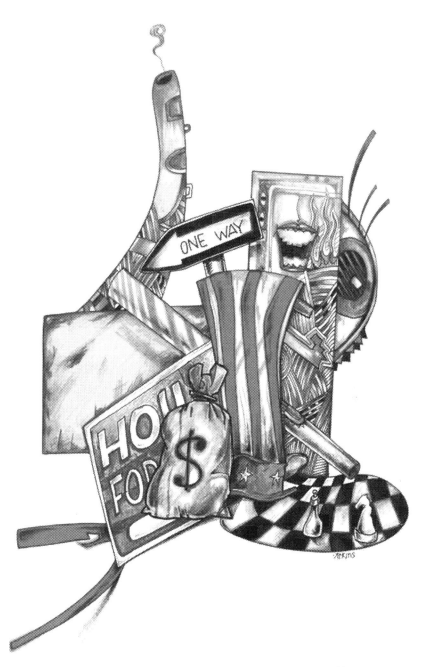

Magician's Top, 2009

Independence

Benefits of wrongdoing are always temporary

You really think you've done something! You think you are a special someone! The facts is – you have indeed done something. You are special. Both in the worst way.

The decisions that you have made in life were done not only in poor taste, but also in the sequences of poor judgments. You have claimed your success in life to be that of passion, honesty, and relatively hard work. What a joke! And you know it! The fact that no one else knows it doesn't change the reality of it. The lies you have told to gain increments of material qualities have taken over any and all aspects of humility that you once had. You have made profitable acquisitions with the use of varied lies and dishonest efforts to acquire a substantial style of living. Your consciousness has been rendered vague and absent, until now.

Before you allow guilt to ruin your thoughts of success, look at it in a different light. There is a good part to all of this. You are not sheltered in total darkness where pain is not factored. In fact, the pain is felt each time you are alone and you face the reality of your achievements. You want badly to be forgiven by God and be judged in a true sense among your peers. However, your pride lurks in the way, keeping you from making such revelations that will disassociate your fictional character from a greater reality. However harsh and difficult it may prove to be, you must relieve these tensions that you've accepted.

Feel free within yourself to live in actuality rather beneath the stones of pretending. Understand that all facades of the untruth will fall and shatter into small fragments, which will reflect a much more negative light on the real you. Cross that road and reveal the most desirable worth within yourself before it becomes even more distorted. Learn to love the real you! It is the only gratification, which will epitomize the most gracious happiness and rewards.

Where to Find Me: in a true world among the living

Redirecting Flight, 2009

Achievement

Your role as a successor empowers your goal to succeed

Are people around you, such as friends and family continuously making you feel bad about what you've become, who you are, and those gains you've made? Does a sense of "you owe me" strike you each time they are within your space? Without a doubt these are characteristics of envy. We have all experienced them in some way or another.

The scenario goes like this: You've worked hard and diligently over the course of your life. You've had nothing handed down to you, but criticism in its most useless form. You have prevailed, risen above the barriers that once held you back. Your gains have brought forth money, power, respect, materialism, and a sense of belonging. Many have sat back piddling around, watching your climb, and occasionally given you a forced compliment, which was never truly genuine. These same people smile in your face and ridicule your blessings behind your back. They are awkwardly nice only when they want something from you. They are your relatives and associates, your church members—the same ones who express their love for you, but only through verbal means.

Because of this behavior, you have forced yourself to make excuses for what you've become. You deny your deeds. You have taken a much lesser approach to demonstrating pride of your hard work. You hardly smile and you no longer welcome compliments. You have allowed other's negative opinions of you consume you. You don't' want to seem arrogant even though you really aren't.

Don't allow those around you, dressed in disguises of envy and jealousy, make you feel ashamed of your accomplishments any longer! Stand in the midst of that which you've acclaimed as you think highly of yourself. The diligence which you've displayed throughout your success is yours and no one else's. Know that those who truly love and adore you in pride are the only people that matters in your life. All others are simply advocates of things less desirable. All others are useless to your life. They want to break you down until you are the same height as they are. Never have they wanted you to excel and they probably never will.

Pray for those negative souls that they one day learn to understand their own destinies, ones that they too can be proud of. However, in the meantime continue the move upward. It may very well prove to be lonely at the top, but remember it is even lonelier at the bottom.

Where to Find Me: grasping pride and voiding the arbitrary shame within

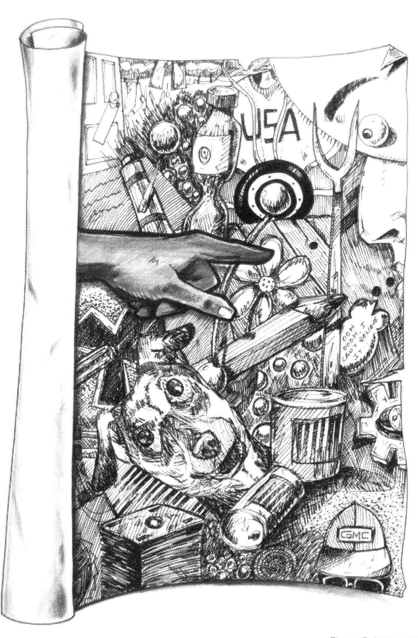

Finger Pointing, 2009

Week 7

To adorn the essence of admiration one should not accept mere satisfaction

Adornment

Sadness is rain in a house

We all have at least one special person in our lives whom we once shared our utmost and personal information, thoughts, ideas, and dreams with. That someone was always near, in spirit and body. Time has changed that comfort. No longer are they standing in the midst of all things real, but they are nevertheless, as present in our lives as the mighty wind blowing from the sea shore.

Problems are circumstances fostered within our lives in a capacity of continuity. They are relentless as they are expected. We cannot evade such natural redundant occurrences, neither can they often be altered to be made less affective. As we continue to maneuver through and beyond these hills of disparity we aim to do so progressively. Often, that productive measure comes by way of factors of the unknown. Have you ever thought for a second that your life was on the verge of complete disaster?

Yes, you saw the totaling end in its most undoubting way. However, the results of that which you projected were overturned. Then, things started to change. Your problems didn't seem so urgent to find resolution. Later, you sat and wondered as to what you owed the credit. Well, it may very well have been divine intervention. Someone from your past, a deceased loved one, heard your cry and sent out a prayer for you. Now that may indeed be a difficult factor to consider, but very well possible to those who bask in the faith of God.

So, for those of us who BELIEVE we must continue to look towards the heavens and witness the trickling down of love songs from those whom we cherished most, for their presence and blessings upon us may be nearer than any seen reality.

Where to Find Me – reaching to find answers toward those persons who mean the most to me, those who have always been dearest to my heart

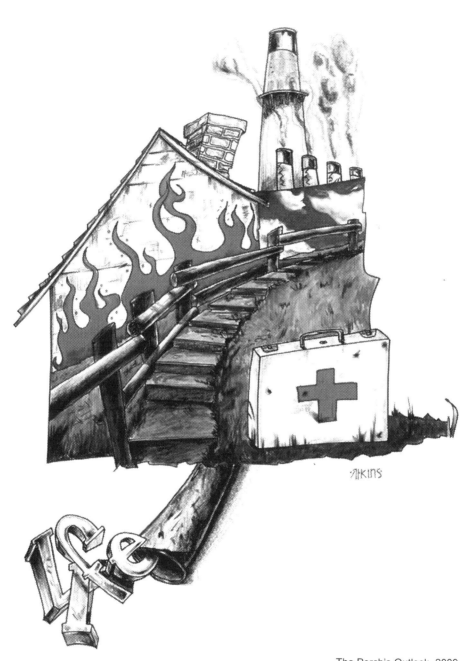

The Porch's Outlook, 2009

Essence

When you discover something that only benefits yourself it is worthless

The gratification that you take upon receiving praise is truly one of humility and humbleness. Your quiet acceptances of awards, rewards, and acclamations have truly been noted as those of genuine quality. Not only do you live quietly in the shadows of pride, but you also have built a house around yourself where small credits can visit.

You are the epitome of love told through a romantic novel of peace. Your character is divine. Stamina of the highest quality is filtered through your heart. You have learned to understand that a single achievement belongs to no one person, but to many it shall spring forth great benefits. You've acquired a great passion for life which could have only been placed upon you by God's touch. Realizing your worth has made awareness to the needs you bestow on that world which surrounds you. You are helpful, kind, and mature. You give those of pain strength and hope. Your presence has become the sun. Life around you blossoms and grows within a field of righteousness everyday that you rise, each night you set. You are a vessel sent from God. A river that flows undisturbed.

This obtained beauty tells you who you are. It identifies you within a methodical calculation. And you are known. It is you who causes our world to prosper in continuum. It is you who foster that which is gracefully granted to those in need. It is you whom I stand for, whom I applaud. It is you who deserves a Standing Ovation.

Where to Find Me: at my bedside kneeling, thanking God for blessing me with the essence of grace and mercy

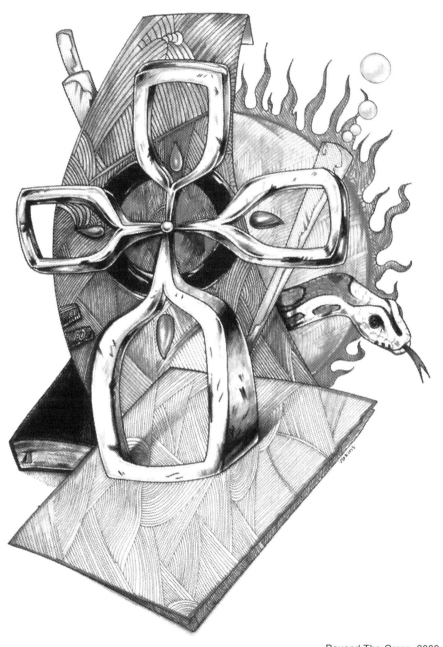

Beyond The Cross, 2009

Admiration

When you acknowledge a teacher you acknowledge future impressions

Gratitude is a feeling embedded within us, but not one that is often spoken. Have you ever assumed that someone knew that your appreciation for them was truly genuine? You have, but you never took the time to thank them. There was a time in my life when I was so caught up, trying diligently to put an art show together for an upcoming exposition. I worked for a length of time without hesitation. I was dedicated to reach a goal. It was something that I lived to accomplish. I was enriched with excitement. The passion within me was overjoyed by the opportunity that found its way to me. I was proud of my climb. With all of that going on, my mind had become cluttered. Not once did I turn to remember those who helped me get to such point of achievement. The credits I was given for my success were well accepted and selfishly held as my own. I was foolish in thought. During that time I realized many things. God places people in our lives for many reasons. Not always will we remember who they are or necessarily what they did for us. However, there is an exceptional cast of individuals that we will never forget. Thanking them may not be at the very top of our list, but it very well should be included.

One day, as I was in my zone of minutia, I sat back and thought of those important things regarding my beginning. My 6th grade art teacher, Mr. Ernest Sterling crossed my mental path. I listened to his footsteps as I envisioned him walking across the classroom toward me. He was a firm and intelligent man. He stretched out his arm and handed me a drawing that I created a day earlier. On the back of the paper was a grade. It was a "C". Attached was a handwritten note that stated: Never Forget the Basics, the Beginnings. Just at that moment I realized what that note meant even though it was 23 years past. I got up, wrote Mr. Sterling a letter and sent him a portfolio of my work. I knew that he was still with me in a sense greater than that of the physical. At that moment his presence reminded me of something. I then understood that all my ambitions would prevail once I found meaningfulness within the context of my life. These memories were short, but effective in my greatest development. I never once forgot about the passion that he, my teacher had for me. He knew that it was most required for what I would soon face in life. From that point on, my veneration for him dwindled within an eminent respect for my commencements.

Like many of life's experiences, you too will rediscover revelations that come to pass in the most unexpected times in your life. These moments are real and unmistakably of a divine purpose. When they come, grab hold and demonstrate gratitude. Take time to show thankfulness toward someone who aided you in achievements, because no matter what you believe, it was indeed those persons who pushed you along the way. Weather discouragement or faith assumes you, remember its strength of inspiration. Motivation comes in the positive sense as it does in the negative. Those of little or no expectations for you are just as important as those who believe you can fly.

It is not always people who love us that are partially responsible for our successes, but also those who attempt to shelter us in a world of absence. But for those who do indeed support us, to them we owe a special ***Thank you.***

Where to Find Me: at that particular place where I can be counted on. Not only will I be responsible, but I will also be passionate about my giving

All 'Bout The Kids, 2009

Acceptance

Those who say what cannot be done have little hope for themselves

The last thing in life that you may want to do is accept someone whom once deeply hurt you. You are not necessarily sorry for not speaking to that person. Rather, you have had a difficult time living with yourself for holding on to a grudge for so long. You should be disappointed for both-not speaking as well as picking at a meaningless sore that is only bothersome to you. Rest assure (if you can) that the person whom you are reluctant to open up to has probably forgotten the reason behind the disparity. They have moved on with their lives, leaving that small minute problem between you two to dissipate into what it actually is – NOTHING.

Don't you want to feel happiness each day that you're awake? Wouldn't it be great to live in peace without a mental burden causing you constant headaches? Do you not want relaxation to be an act of natural occurrence, rather a methodical decision forced upon yourself? If NO is your final answer to these questions, you truly are in desperate need of a plan to rise above this circumstance. However, if yes is undoubtedly at the end of your thought, then you are on your way to healing.

Climb out of that old torn skin, kick it off from the ankles, and place it in a pile of rubble. Next, take a match and ignite all that has caused your life extreme pain and discomfort. Once you find that new wardrobe of revelation then you will have the strength to move toward freedom from agitation. In this new place the lights are brighter, the food tastes better, the rush has become slower, and your vision has more clarity.

Today, make an appeal. Terminate those useless things of a broken heart. Release yourself into an area that is no longer dominated by painful memories that senselessly absorb your air.

Where to Find Me: in a state of mind where the lapse of time has become my strength

Baby Sitting Ernestine, 2009

Satisfaction

Satisfaction is not a reward of mediocrity

Dissatisfaction is a tolerable disease that many of us have learned to live with. We cope within its limitless boundaries each day of our lives. We have assumed the role of becoming victims of this seemingly non ending tragedy. We are aware of its consequences and we realize that its continuation will gain momentum in days to come, yet we show no or little hesitation to treat it.

Displeasure is generally associated with an unfulfilled desire. We want so much that we don't have and may never obtain. One of the greatest reasons for this is because we are not willing to put forth the necessary energies, time, and efforts to make claim.

*We want to become a millionaire by purchasing a potentially hopeless lottery ticket each week, instead of educating ourselves to become independent business owners.

*We want to find and marry that perfect person who may prove to be our soul mate. However, we are constantly looking in the wrong places for love. We are engaging in marital affairs, which makes us less desirable for commitment. As the old saying goes – "Why buy the cow when you can get the milk for free?"

Regardless of how badly this sounds do realize that there's a cure for dissatisfaction. It is in our hold. It stands before us. We must move away from dependency of others and unlikely things that gives us a false sense of hope and reality.

For satisfaction to reveal itself and find a place in our lives we must learn and adapt to those methods which can and will assure us of its presence. We must put forth the hard work necessary to achieve. Stop looking for quick fixes to problem solving. Discontinue hopeful romantic fantasies upon highly unlikely dreams. Move out of reach of those elements, which strive on the partaking of your misery. Learn to love yourself first. Reward yourself through the talents and gifts that God has placed upon you. Then, and only then shall the height of your potential endure!

Where to Find Me: in a clear mind state where thoughts of dissatisfaction can no longer thrive in the premises of my soul

Flight Of The Crow, 2009

Week 8

Often the aptitude of unhappiness is a façade
of envy's deception

Aptitude

There are two ways of thinking, positively and negatively, but only one will prevail

Blinded by the absence of light, I felt my way through the darkened space of transience. There was no opportunity to turn back toward the illuminating projection where a crackle of light was present.

As I envision that particular moment I see a place where many of us were born. We found life in the midst of nothing materialistic. There were no silver coins falling from our skies. No steaming aroma of edible delights made their way to our dinner table. And there were no comfortable structures of softness to caress our backs as we slept at night. Poverty Stricken was our first and last names. But, Oh . . . how soon have we forgotten. Convenience is the only time when our outlets are serviced. The only time when we remember. Our past is only to be recalled at our family reunions when the elderly gather for devotion and the "Remember When" stories are spoken of. Even then we hide in shadow. Our new-found identity does not grant such attributes. Retrospective appreciation is definitely not one of our strong points.

We have fooled many people. Those who surround our new world have no idea that such aspects of our lives even existed. The more we forbid ourselves from others the more hidden we become from our existing reality. We should bring the bridge of our noses down a notch when we walk past the homeless woman pushing the converted shopping cart. The frown upon our faces should be wiped away when a 3 star dinner is mentioned to us. We have transformed into a configuration that holds no truths at all. We are ZUMBIFIED within this small, unimportant world that we bask in. Some call it society. Others refer to it as lonely areas searching for openness where so-called admiration dwells.

Let us stop for a day. Discontinue the battle to be better than THEY and realize that our world is the same one that evolves around everyone else. Let us grasp a hand that is in need of holding and guide someone beyond those limits where we once peered from. Let us not forget where we came from. We owe it only to ourselves to be enriched with the presence of someone in need. We owe it to ourselves to return to our beginnings and appreciate each and every step made forward in determination. We owe ourselves the honesty and respect from which we were made.

WHERE TO FIND ME: standing beside the stranger who needs me. He looks like me, moves like me, thinks like me. I am him. We shall move together in search for opportunities to make the most difference

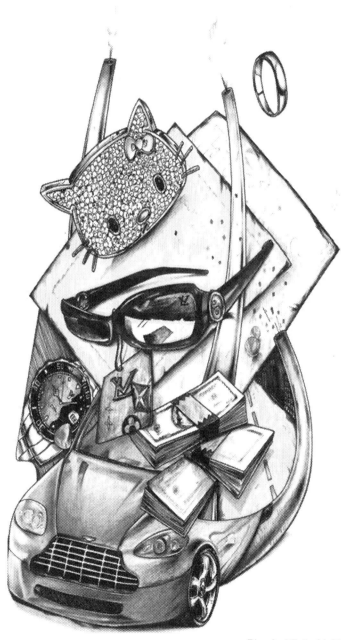

Rise And Fall of A Shadow, 2009

Unhappiness

To highlight imperfections of others is to illuminate our own

There's nothing worst than a person who condemns the character of another to gain a sense of false placement. It happens all the time and we all know of such person. Some of us know more than one. If we look into such description carefully, we may in fact see ourselves as that person.

You know that person who walks around "hating" on everything and everyone who has the nerve to move forward through positive means despite of discouragement.

This type of person suffers from something that is deadly and is filled with the potential to become contagious. When you see this person coming your way – RUN! They pray on the week. Hardly do they find acceptance within a group of thinkers, those who make their own decisions based on higher standards.

Those who will serve as an audience for them and partake in such belittling are usually their target. A sort of fan club.

You'll recognize them when they show up. The disease is on their tongue and stems from traits characterized by their own uncertainties. Their conversations start off only a few ways: "Hey, did you hear . . ." "Guess what I heard the other day . . ." "I'm going to tell you something, but you have to promise me . . ." "You are not going to believe this . . ." The list goes on and on.

However, there is much we can do to discontinue and evade the coarse of impudence. Block each cheap shot that they take. If you don't they will pull you into their game so fast that you'll immediately become part of their team. They're losers! And there's nothing exciting about being on a team of losers.

Either persist on the opposing team or stay on the side line and be observant. Try not to get in the way of loose balls. Allow God to make the calls on their violations. He is the referee. One thing is for certain—God never allow cheaters to win.

Be nice to people and uphold your best morals. You may never know what blessings will follow.

Where to Find Me: far away from those who fill the air with badgered and unproductive talk

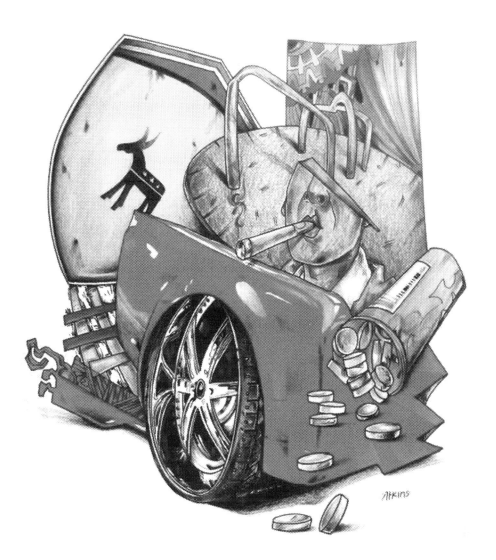

Watchful Perspective, 2009

Façade

Don't confuse concern with that of envy

As painful as it might be, we sometimes have to accept the fact that not everyone who smiles at us really and truly have our best interests at hand. This is more than a universal thing. It is a personal one.

I like to call those persons who engage in mere happiness at the site of someone else's failure "HEMBU". Although not clinically proven, these individuals suffer from an infestation, which characterizes hatred as the first onset symptom. The worst part about this disease is that the real cure is very seldom sought after. Instead, it is strengthened through other individuals potential shortfalls. We all spend too much time worrying about what others say and think about us. It's not important!

We all know of that one person at work who is always engaged in redundant behavior of rumor chasing. The same person, most likely one with very little faith in self accomplishment, has the tendency of gaining internal excitement when someone else lack achievement. The HEMBU (Help Me Be You) is easily identifiable. They only speak to you when you're on the verge of a life promotion. Snooping until they can find a glitch in your plan to rise is their specialty. They can't be avoided because their goal is to find you. And they will!

However, don't allow the HEMBU to deny you the remarkable joy that shines upon your life. Remember, that this person was never a part of your plan to succeed and they surely aren't a factor now. Allow them to bask and wallow in the slop that they live in. Continue your focus and become more persistent than ever before. Use the HEMBU's disease as a constant reminder that you don't welcome such a plague into your life.

So, pursue what you've put so much of your hard work and time into. Keep looking ahead because that which you've longed and prayed for is just behind that door. And as you discover yourself in the world of trial and error, do so in the most beautiful light of illumination. Only then may the HEMBU realize that your shining light of determination may in fact be theirs. And then, suddenly, they shall be cured.

Where to Find Me: in the midst of those who hate what I stand for, but staying in lead

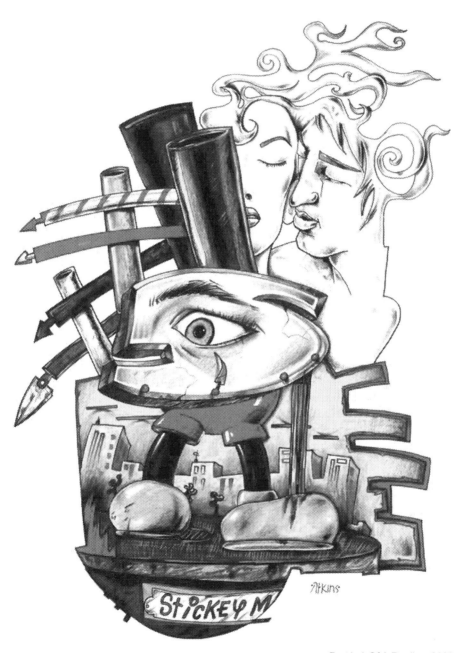

Protégé Of A Replica, 2009

Envy

Progress is seen through the works of man and heard not from his tongue

"Non Stop" is seemingly the two words you constantly assume when it comes to your daily struggles. They are endless. Not even for a brief instance where you can clear your head or even inhale a flow of clean air is near.

This struggle is everywhere and will continue to be everywhere. We all find it at our doorsteps more than occasionally. It knocks with no official warning. It doesn't even call before stopping by. Somehow it just knows how and when to find us. And the sad part about it is that when visiting it doesn't know when to leave. Struggle never has a problem wearing out its welcome.

What makes matters worse is when we look around and notice others finding their way beyond struggle. We ask ourselves with envy: How do they do it? How can they be happy when I make more money than they do? Why do they smile when my family is right here with me? How do they get all of those benefits and services when they don't even have a job? Why? How?

The questions never let up. Unfortunately, they too are relatives of "Non Stop". And since we don't have the power to discontinue these questionable things from happening in our lives we must discover a way to change the course of such inquiries. This will take a lot of doing and effort on our part, but it can ultimately be achieved. The first thing we must do is discourse the beliefs of our failures as well as our deficiencies. We must learn to view them as inclinations that we gave up before we reached our goal. Failure can never make itself seen until we stop trying to achieve. So, in relevance, we too have to become members of "Non Stop".

Many times, we give up on ourselves, thus creating a forum of depression and sorrow in which to dwell. Impatience is the key virtue which sickens us. The second thing we must do is discontinue to live in comparison to those around us. Just because they have one thing doesn't mean we should have the same. God did not create everything to be spread out equally. He put a little here and a little there. A gracious balance for all of us.

The sooner we see reality for what it is, the sooner we'll learn to love who we are.

Where to Find Me: in a "Non Stop" world where I won't quit until I realize the achievements that God has granted me

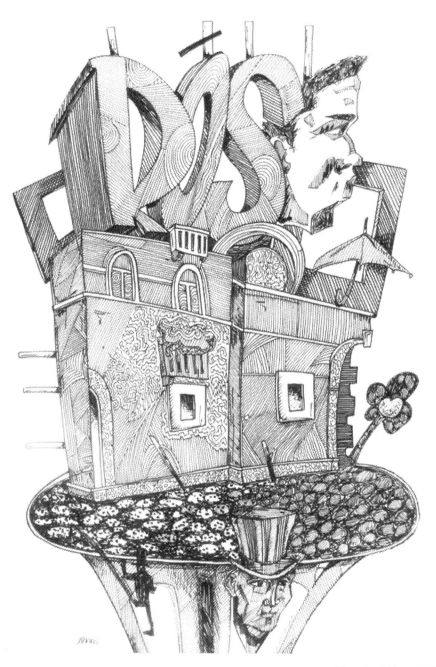

Triumphant Horn, 2009

Deception

The true measure of a man is characteristic of priceless things

Are you tired of living a life of dishonesty? Each and every conscious moment in your life is filled with delusions. Even your dreams are compiled of fanciful fantasies of things far from truth. Point blank – there is no truth in you!

You have spent so much of your time trying to continue imaginary false fronts that it has truly become your second job. It has no merit. The problem with such moonlighting is that your compensation hardly adds up to the time which you've actually invested. As you drift momentarily into wonders of retrospect, do realize that not all of your actions are to be blamed on you. Yes, you are indeed your own person, but you have been inspired to become this person of falsehood.

Your upbringing as a child most likely has had the greatest baring on your disposition and how you relate to others. All of your life you have been molded to think that having more not only makes you better, but also makes you more accepted among those whom you attempt to impress. You have accepted the idea of "truth deviation". It has become your common.

Stop being dishonest about the number of sexual partners that you've had. Your merit is not calculated by how many orgasms you've claimed. Stop telling mythical stories about materialistic things you own. True character is not defined by your wealth. Stop your tongue from spilling untrue facts regarding your acclamations and achievements. Your measure is based on actual doing, rather than verbal imposters. Stop falsifying documents to acquire financial gain. A little more money now may result in a lot less later.

Before you go out and purchase those garments and accessories that you can't afford or just before renting that dream car that you may never own, or lying about that fancy home that you don't have – RETHINK.

Understand that your acceptance, which is based on the reality of who you are and what you have is the only one worthy of your time. Faking to be more has only caused more pain for you. The lie that you live will soon come to an end. And only then will you see what you've known all alone . . . You'll see that being truthful has the greatest benefits in life. All of the people who genuinely accepts you do so out of nature, rather than an episode which you have forced them to watch.

Where to Find Me: in the luxury of myself where I can be fee from the burdens of fraudulence

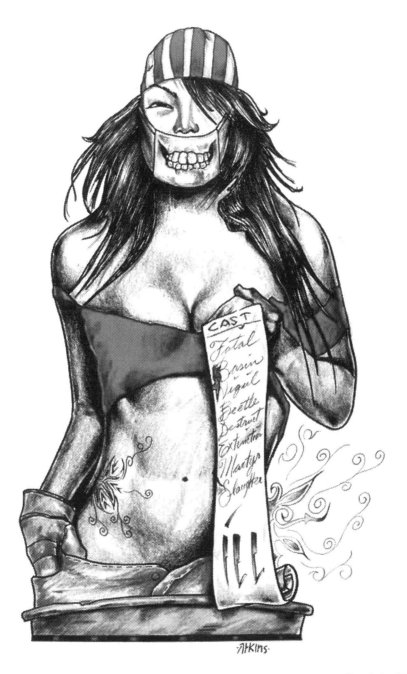

Turpitude, 2009

Week 9

*To understand the expectation of subtleness,
one must conquer invaluable responses*

Understanding

Intelligence is a quiet thing that does not have to be self proclaimed

Let me start by telling you how important it is to let go of the self-centeredness in your life. Just like most of us, you have the ultimate investment in something that is totally invaluable. That something is you. However true, arrogance has consumed you.

But I don't want to stall there by telling you of how adorable you think or even know you are. On the contrary, not everyone holds that same admiration for you. Not even your spouse, loved one, or significant other places you on the pedestal you feel you belong.

Not only does this factor make you feel uncomfortable, but it also gives you a sense that those persons lack support for you and the endeavors you seek. A dependency of their supportive justification has formed into a need that you can't bare to live without.

The fact is this: They are not interested in everything you do, nor will they ever be as interested as you are. Your goals are not always theirs and they may never be. You feel as though the two of you are not, have not been on the same page. Well, maybe you're reading too fast.

Whatever the case – the issue has to be resolved. Just because you don't agree with the methods that your partner uses to display their supportive roles in your dreams, does not mean that they don't love you. Neither does it mean that they don't care about your interests. Take time to see where they stand on the matter. Not always do support come within a standard and predictable sequence. Often, it derives from a source unseen and is shown in a method of what we view as mild simplicity.

The need for this desired support is just that. It is not necessary for you to be told time after time "you are doing a great job, Honey." These are words that should be embedded within yourself. You should speak them daily without confirmation from others as your confirmation of progress.

You are an environ to those things waiting to be touched. Your hands are the ones necessary to reach that endeavor. Your partner's hands are only meant to give you that subtle push that may move you closer. Ultimately, it is your grasp which holds your future.

Where to Find Me: in an independent mindset calculating progressive gains without dependency of others

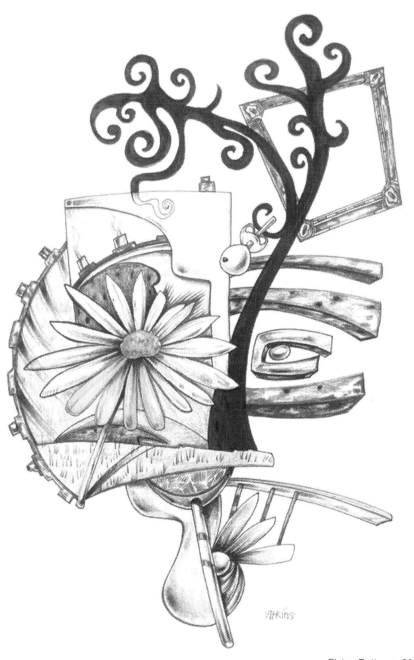

Flying Buttress, 2009

Expectation

All gravel roads have potential endings so avoid them

We wake up, go to work, pick up the kids on our way home, cook dinner, catch the news, and retire for the evening. Tomorrow, we do the same thing in the same sequence. Or . . . we change our lives.

Each of us have our very own comfort zone. Yet, we are hesitant to change even those things that we find so redundantly boring. Complaining is what we have become an advocate for. Understand that change has to be greater than a desire. It has to be a factor that promotes us. A destination has to be in our view. Passion accompanied by a meaningful plan has to be instated to make any and all possibilities of change to come to fruition.

There are so many things we want to do in our lives before that last day to look out reaches us. But we don't know how or where to go for motivation. The fact is that motivation is something that is often self-inflicted. People around you can attempt at moving your spirits and highlighting your worth. They can evoke a thoughtful movement within you that may fade faster than implementation. However, until you can see these factors for yourself you'll continue to wake up in the morning holding the same agenda. Slobbering on that same pillow.

Where to Find Me: searching for that which fosters greatness

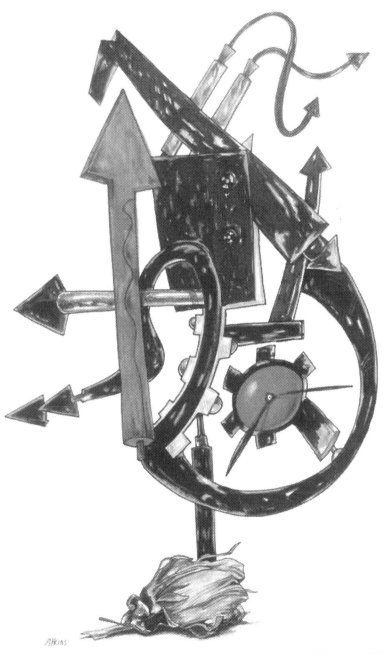

Prisoner's Walk, 2009

Subtleness

The one thing we never outgrow is the need to be loved

It is time you began trusting again! You have reached a point in life where you feel shameless and useless to the world. It feels like you have been eaten alive, chewed for a while and spat out with only a small portion of yourself left. Disappointment has found you on so many levels. You once had a dear friend whom you once trusted wholeheartedly, one you cried to and confided in. This individual was always close, just a phone call away.

Suddenly, there was a change. The secrecy between the two of you became an open one that was shared with the likes of others. The trust you once shared dwindled into a minute abyss. Betrayal took its place. The love of your life finally, after a very long time, made a committed vow to you. Your love was so strong. It was seemingly endless. You can still recall the wonderful times when the two of you walked close together hand in hand while constant chants of "I Love You" flowed from your lips. Now, that once true love has moved on to someone else to share those same words given to you. Your harmony has been interrupted. It was replaced by heartache. You have lost trust in God, the one whom all of your decisions rested. Constant wondering enter your mind as to why he allows so many terrible things to happen in your life. Doubts of his existence have taken over those of faith and belief. An evil spirit has come to visit. With all of these things going on in your life, you are consistent on keeping yourself together the best way you know how. The fact is, these things of unfortunate measure are all results of uncontrolled circumstances. They were not planned and never did they cross your mind. The fact is, you are still here, still rising above all that which you thought defeated you. You still have not realized that you have won the battle.

GOD has not forsaken you! He is very well and continuously in the midst of everything. He has only allowed enough to happen for you to grow. The statue of your character is growing and developing into something of greater importance. The point has come for you to let go of the past, value the present, and love for the future. That is the only way you will become free to move toward prosperity. True love and friendship will soon find you. God will navigate those things your way. He wants you to acknowledge him undoubtedly. It is time that you receive, through welcoming arms, those things that you have always felt deprived of. And they will come.

Prideful, you will stand because God Loves You.

Where to Find Me: within words that define trust. I will follow my heart because I am confident that it will guide me in the direction that is best for me

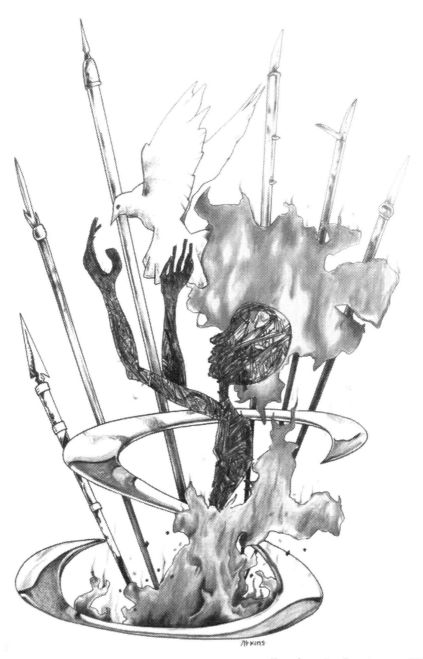

Transformation Renaissance, 2009

Conquer

When you smile at your enemy you take away his power

A particular time in your life has proven to be more damaging than anyone could have ever imagined. It all started when you were just a child. The oppression, the abuse, the blame, and even the mental anguish has formed you into this person which you've become. This image has taken on a personality which is distant from society, sheltered from family and friends, and has fallen into self-abandonment from the world. It is you. Tears brought on by unforgettable pain is the only sense of life you have. The only sense of being which you identify yourself.

Not only are you fueled by constant anger and disgust, but you are overwhelmingly scarred by this reality that has stolen your self esteem, motivation, and ambitions. You feel helplessly ashamed by that which has molded you. You feel unwanted, undesirable, and without hope. YOU FEEL WORTHLESS!

You've done yourself very little favor by accepting the consequential burdens of being unhappy. In fact, you are slowly and painfully dying as a result. But you don't have to anymore!

That day has arrived for you to find the courage to overcome these problems that have infringed upon your life. The day is here for you to climb out of that hole of which you've been hiding, dust yourself off and face those forsaken challenges. You are stronger than you think. You have more courage than you realize. You are greater, much greater, than those elements which have attempted to break you. That day has arrived for you to walk closer and approach all that has hurt you. That day has come for you to stand, claim victory, and lay those burdens down which you've held within your grasp for all of these years.

Uphold the dignity which you have. Smile toward that bright lit sun that illuminates before you. Those old things, bad memories, and horrific realities have controlled you long enough. That day to be a winner is closer than ever. It is here! It is now!

Conquer those things that have taken hold of you. Free yourself of these forbidden chains.

Where to Find Me: applying the laws of happiness to my life so that the restraints of pain can live inside of me no longer

Intermediate Start, 2009

Response

Embrace those of negativity for they are of encouragement

Caught up are you? Ha, you are! So many things make that statement one of great validity. You are so far gone that you have begun to neglect everything that use to be important to you. Your family, your friends, work, and first and foremost, your trust in divinity have all been placed on the back burner. Not to simmer though. Actually, those things are just sitting back there. The oven is not even turned on.

It is like your head has been taken off of your body and tossed toward the clouds. You only look down at people when you see them. The time you shared with them, the commitment, has all been deleted from your interests. What you all had together is no longer of any importance. You now have better things to do-so you think!

Advice. Slow down before you find yourself looking upward towards people with your hand extended trying to get someone to pull you from the whole which you gracefully and selfishly dug.

Realize that anything that was of importance to you before your new discovery of overwhelming happiness, still will be if your caring was genuine. If it wasn't then just continue to let it drift off into what it is—Nothing.

But if your conscious has poked you and gained a bit of your attention you must acknowledge it. Act on it as you listen to the inner linings of your heart. You may have made a mistake by accepting something or someone into your life, which has had a negative effect on relations with others. You may have once believed those interferences to be dear, but as you continue to see the evolutions you realize that worthiness is of no association.

Being caught up makes you do some things you wouldn't ordinarily do had your focus been left uninterrupted. Take a few steps back so that you can view the picture with greater clarity. See the mistakes you've made. Know that it's not too late to mend those broken aspects which have been overshadowed by extreme neglect. Make amends once you've forgiven yourself.

Life doesn't have to end here so, don't allow room for such manifestations to grow.

***Where to Find Me** – on a balancing beam catering to those important things in my life with the highest regard*

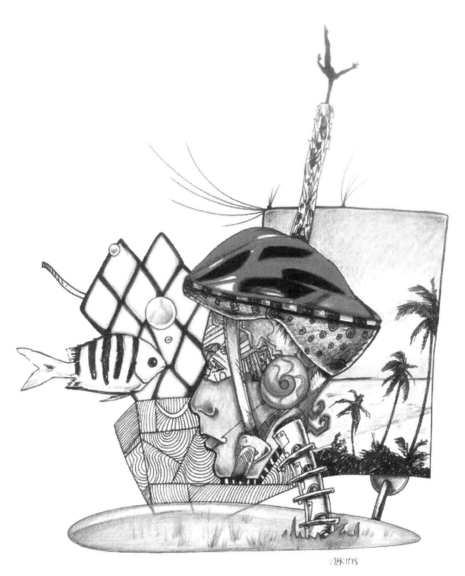

Safe Fish, 2009

Week 10

*Growth's acceleration is based
on the manifestation of defeat's travel*

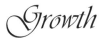Growth

To change the course of stress one must be open to prevention

Many of us suffer from headaches. Each day we awake one is throbbing inside our heads. When we attempt to sleep it informs us that falling asleep will be challenging. The many doctors that we have visited have told us just what we expected them to say. They seemingly never have the right medicine we need that can actually prevent them. We leave their offices ridiculing their medical practices and professionalism. After all, it's just a headache, one that has a maximum control over our lives. In fact, it has been the single most expectation that we can definitely look forward to. So why can't Doctor X give me a little tablet to relive the pain? There are pills for everything these days.

People, it is time to rediagnose ourselves. We must look in depth to the source from which our pains derive. These evaluations will indeed be time consuming through methodical procedures of self-analysis. Our headaches may very well be resulting from the unclear visions within our lives. We haven't been worry-free since the age of 7. Since then, our lives have been filled with pain, chaos, depression, and that which has given us thoughts of life's ending. This is really no way to live. The solution to the source of our problems, which forms in the core of our minds as headaches is not a simple one. However, it can be cured. But only by those whom it directly affects. THAT'S YOU AND ME. Discover what causes you to worry. Maybe it is your relationship. Your spouse may be cheating and you don't know what to do about it. Maybe your children are causing you heartache with their menacing behaviors. Maybe your job has placed more pressure on you than you can bare. Or maybe you've closed the door to the world and now live a lonely life of boredom. Maybe you suffer from the disease of more than 99% of the world . . . not enough money.

Whatever the case, all things must be turned over to the hands of God. Really and truly try prayer and ask God to eliminate the burdens within your life. Even if you've never tried God and you don't believe, try God anyway. You have nothing to lose, considering all other attempts have failed you. You will not be judged in a sense of unworthiness. On the contrary, you will be welcomed with open arms and a new chance at healing.

Where to Find Me: on my knees passionately and whole-heartedly asking God to dismiss the burdens of proof of our disobedient ways

The Clutch, 2009

Acceleration

Be careful of your knowledge, you may have to share it one day

Wow, you are really something!

You have finally done it. Your accomplishments have proven to be that of diligence and hard work. Even though the odds have been unfavorably against you, the drive that you possess is definitely one that is desired by most. So many things have pushed against you. So much has happened in your life that could have undoubtedly strayed you from fulfilling the endeavors which you obviously have ownership of. Times came and went again and again when you just wanted to throw in the towel.

You wanted to quit when the run got longer. You wanted to turn around when those doors slammed in your face, but instead you knocked on others until you found the right one. You climbed many small mountains of "no" until you reached that one "yes."

The epitome of persistence you are. The redemption of all dreams deferred you have claimed. The societal world will hold you in a light for all to see as you become the poster child for achievement. Many will look on with astonishment, attempting to discover that which you've welcomed into your life with extreme comfort. You will serve as a role model, an inspiration, and an individual of good character. Your momentum shall transcend into the lives of those who dream as you have. CONGRATULATIONS!

Use this new forum of exceptional quality, not for your own platform, but one where those whom you inspire can soon stand upon. Realize that which you've been blessed with and observe the purpose of it. It stems far from your personal grasp. Its design was meant to be adorned by those who stare nearby and those who strain to see from afar.

Life is good now, but to help someone realize their greatest achievements, it will become better tomorrow, for everyone.

Where to Find Me: standing next to my pedestal aiding someone else's climb to the top

Pumpkin Head, Oh Pumpkin Head, 2009

Manifestation

Modern slavery is not a result of race, rather the individual who refuses freedom

Do you remember when you first took the steps toward finding your purpose in life?

The problem with that quest is that it is a continuum. You have desperately committed yourself to finding self-worth or at least a small sense of it. Finding meaningfulness is not as simple as you may have initially thought. The key word In that last sentence is FINDING. It may be time to discontinue your goals that are driven by self-discovery and allow your purpose for living to ascertain you.

One of the most unforgettable times in American history came in 2008, during the Presidential Election. President Barack Obama found himself in a far-out victory against his opponent. I suspect that such particular moment for him was grand, to say the least. No matter what his feelings were initially, or how excited his followers were for him, one thing was for sure—he would soon become America's leader. The one whom was expected to lead the nation through the current crisis and those which awaited in the distance. His purpose in life was perhaps not to seek the highest ranking chair within his country one day nor it may not have been for him to become a role model for the many people whom he inspired with a vision of hope. However, perhaps his purpose in life found its way to him.

We too have to stand in the meantime and patiently hover over ourselves waiting for that moment to arrive. It may not come when you want, but within the shadows of faith you can be assured that your purpose in life will show itself when you least expect it.

So, continue the good and the great things that you share with others. Slow down none when it comes to making those decisions, which may foster in the aiding of those in need. You are a gift that has yet to be unraveled. You are that hand, which keeps on giving. You are undoubtedly a sole standing in the path of deservance where blessings will shower down on you with more love than you could have ever imagined.

Follow your heart to the end of your last breath and you will realize that your purpose was evident all along.

Where to Find Me: in accordance with those things which God has allowed me to touch and continue to touch till my presence is no longer physical, yet beyond

Statue Of Faith, 2009

Defeat

It's difficult to make improvements in life when we are our own role model

BAM! As blood drip from the corners of your mouth, you feel a horrific pain throbbing around your left eye. It has turned black and blue. You have 4 broken ribs, a fractured leg, and a broken arm. You have been beaten by the hands of the world. Something tells you that there is no longer any fight left in you. You sit in your corner contemplating if you should pull the trigger or not.

A description of life and the role you play in it is metaphorically paralleled. Your adrenaline has weekend. You attempt so hard at success, but only find hardship. You call on God each day through prayer, but God seems to be too busy to answer. You walk with a straight posture as you move proudly and responsibly toward open doors of chaos, but they slam in your face. You move within a continuum of persistence. You help by donating time and money to the less fortunate, but no one says thank you. You care for and try diligently to teach the young people so that one day they will achieve success, but they are not attentively listening. You always come running when someone is in need of your help, but they are never in a position to run for you. You cry tears for the less fortunate even when your teary river is on the verge of drying up. You give, give, give, and keep giving even when your very last has already been given. At this point in your life you see failure's face – in the mirror.

You awake to the morning sun to face the same fate as yesterday with little hope of a different outcome.

What you don't notice is the greater part of you that has been blessed to be a blessing. No longer should you endorse the thoughts of misjudgments upon yourself. You have proven and continue to prove that your drive is endlessly driven by God. You have a power greater than any strength. You have the passion and will to conquer. It is not a matter of if you will. It's a matter of when. You have already defeated defeat.

Where to Find Me: in a place that will allow me to become stronger than ever before. I will be productive in my own world and self accomplishment will be my greatest goal through spiritual guidance

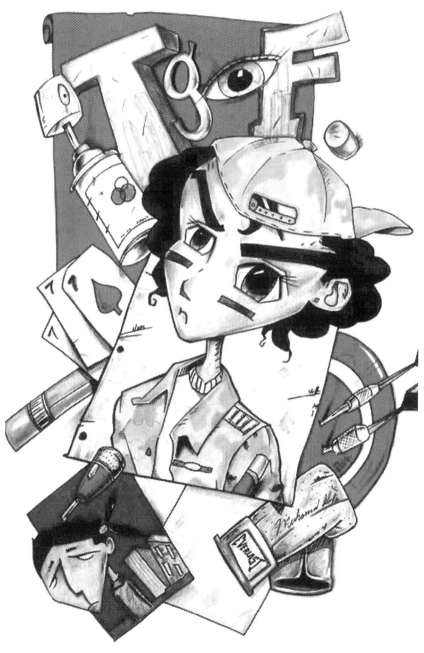

Rift Overturn, 2009

Travel

The stronger your vision the further you will see

Have you ever turned down a road to find out that it had no outlet? You had no idea where you were headed?

Life is the same way. Every now and then we travel unexpectedly down that long "dead end" road. Some of us even experience relationships that prove to be a waste of momentum. Many of those relationships are limited by the bounds we break. Sleeping with someone else's husband or wife is indeed one of the most notoriously dreadful mistakes that we could make. However, this practice is becoming more common each day in our society. It has become a random act with very little consciousness of consequences. It all begins with the attention factor. You love it, always have, and seemingly this is the factor that always has to be present for you to feel like someone special. Someone tells you that you are attractive and it starts from there. We become defenseless.

There are often a number of factors that makes vulnerability a part of our persona. Things at home are up and down like a roller coaster, but mostly at a descent. With a welcomed force, we are pulled away from these issues, commonly by someone induced. They have convinced us that they are in love with us over a period of time. The worst part is that we have convinced ourselves that it is true love. *It is not!* True love, does not only deserve total respect, but it also requires such. Some behaviors will not grant such rewards. Commonly, this other person makes us feel needed, wanted, desirable, beautiful, and important, but we already knew those things about ourselves before such spiritually prohibited behavior. It was not necessary for another person to tell you what you already knew. These simple compliments that are given to you have become your desire. It is just as fake as it is UnGodly. Stop the foolishness! Stop subjecting yourself to this low expectation. You are stronger and more willful than that. If things are extremely unbearable at home dismiss yourself from such place and begin living openly and freely. Your life is precious to you and to God. So, stop endangering yourself to the many challenges that comes with infidelity. Most likely, no one is going to treat you with any more respect than they have demonstrate toward their spouse. So, don't be fooled. You are simply a temporary means for artificial joy, one who shall live in misery, thereafter.

Remember, joy is often expressed loudly with great honor, but sleeping with someone else's partner is an affliction that lives hidden from the world in total silence.

Where to Find Me: in a nondependent environment where I will no longer place my faith in the hands of earthly beings, including myself. I will confide within my understandings with that of greater power

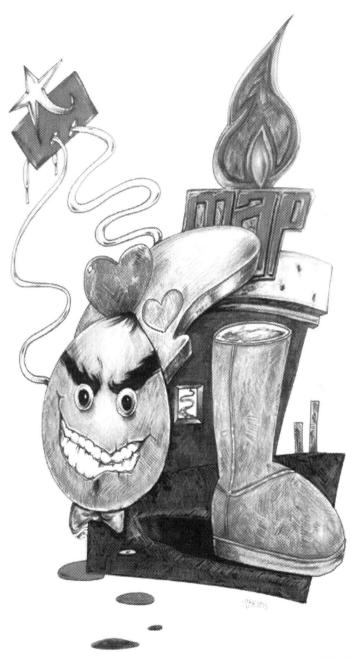

Tough Gone, 2009

Thank you for engaging in this attempt at self discovery. Indeed, I hope that your experience will prove to be much greater than that. However, do not allow these words and images to become those of temporary means and that of the past. Rather, keep them close so that they may live within your pulse where growth shall foster in and between each heart beat.

Remember, as long as you have a breath in your body – you have life. And when there's life, there's opportunity to change all imperfections that deny you total freedom.

LIST OF ILLUSTRATIONS

(all images where created with colored pencil and ink on stock paper)

The one thing that's greater than love,
happiness, wealth, beauty, and power is IMAGINATION.
With IT we can have all of those things at once